AUTHENTIC ART DECO INTERIORS AND FURNITURE
IN FULL COLOR

Edited and with an Introduction by
JEAN L. DRUESEDOW

DOVER PUBLICATIONS, INC.
Mineola, New York

Copyright

Copyright © 1997 by Dover Publications, Inc.
All rights reserved under Pan American and International Copyright Conventions.

Published in Canada by General Publishing Company, Ltd., 30 Lesmill Road, Don Mills, Toronto, Ontario.
Published in the United Kingdom by Constable and Company, Ltd., 3 The Lanchesters, 162–164 Fulham Palace Road, London W6 9ER.

Bibliographical Note

Authentic Art Deco Interiors and Furniture in Full Color is a new work, first published by Dover Publications, Inc., in 1997.

Library of Congress Cataloging-in-Publication Data

Authentic art deco interiors and furniture in full color / Jean L. Druesedow (ed.).
 p. cm.
 Compilation of 108 plates from Répertoire du goût moderne. Editions Albert Levy, Paris, 1928–29 and other French design portfolios, 1924–1926.
 Includes bibliographical references.
 ISBN 0-486-29635-0 (pbk.)
 1. Decoration and ornament—France—Art deco. 2. Interior decoration—France—History—20th century. 3. Furniture—France—History—20th century. I. Druesedow, Jean L.
NK2049.A1A94 1997 97–21828
747.2'44'09042—dc21 CIP

Manufactured in the United States of America
Dover Publications, Inc., 31 East 2nd Street, Mineola, NY 11501

INTRODUCTION

Editions Albert Lévy announced with the first volume of *Répertoire du goût moderne* in 1928 that there was no doubt that something properly called "modern taste" did, in fact, exist. It was also claimed that this phenomenon was no longer restricted to an elite but had won over a significant part of the wider public. It was to be the purpose of the five volumes of designs included in the *Répertoire* to provide a catalog of the "thousand aspects of the modern interior as it was wanted by all those who wish to be in step with modern times" in a way that provided practical solutions to the "organization, furnishing, and decoration of an apartment." For this purpose the publisher assembled a number of artists who were in the forefront of modern interior design and asked them to provide ideas for complete decors as well as details of furniture, textiles, fixtures, and other objects that would yield a consistent and accessible modern aesthetic.

The recognition that a modern lifestyle required new and practical design solutions had been a tenet of the Société des artistes décorateurs since its founding in 1901. In the Société's annual exhibitions all aspects of the decorative arts were included, and the twentieth-century renaissance in French decorative art can be attributed to these important events. The Société's participation in the Exposition internationale des arts décoratifs et industriels modernes in 1925 gave the Art Deco movement a lasting and worldwide impact. As is often the case in a stylistic movement, two points of view toward modern design emerged. Some artists emphasized elaborate ornamentation and intricate, hand-crafted surface design while others sought the unadorned reflective qualities of industry-produced glass and steel and the impact of geometric planes. These two viewpoints implied differing political attitudes as well, with the former group more conservative, the latter more avant-garde; the former working for an elite clientele and the latter more egalitarian in its desire to provide functional modern design to a wider public. There was also an effort by the Société and the French government to protect the French artisans from the incursion of industrial production implicit in the new International Style that was gaining critical acclaim. These differences led to the fracturing of the Société in 1929 and the subsequent formation of the Union des artistes modernes.

Published during the years 1928 and 1929, the *Répertoire du goût moderne* came at the peak of the controversy and included, without comment, designs from artists on both sides of the issues. However, most of the designs seem to fall on the side of those influenced by Cubism and the possibilities represented by industrial production. Many of the artists were trained as architects and considered furniture and other aspects of interior design to be governed by the requisites of space and not as independent elements. The emphasis in the *Répertoire* on living space used for multiple purposes was in keeping with the sense of a new and modern lifestyle that often implied smaller spaces as well. Built-in furniture, cleverly arranged areas for different functions, and clean straight lines all made such living arrangements more agreeable. The inclusion of offices, classrooms, bathrooms, kitchens, and children's rooms made the *Répertoire* especially relevant to the modern need to rethink the use of space and interior design. A recognition that physical exercise was an important component of modern living was also addressed, as was the increasing presence of the studio apartment. The living room that could include space for dining as well as comfortable seating was another new idea explored in the *Répertoire*. Luxurious residences were not ignored, and in the final volume more formal rooms such as salons and libraries were also illustrated. In the end the publisher of the *Répertoire* fulfilled his goal of providing solutions to the issues raised by the rapid and profound changes of modern life.

Fifty-five of the seventy-nine illustrations in this volume have been reproduced directly from rare original plates from the five volumes of the *Répertoire du goût moderne*. The sources of the other illustrations are as follows:

Une ambassade française organisée par la société des artistes decorateurs; exposition internationale des arts decoratifs et industriels modernes, nos. 11 and 54. Paris: Editions d'art Charles Moreau, 1925.

Décoration moderne dans l'intérieur, nos. 2–4, 12, 30, 31, 47, and 53. Paris: S. de Bonadona, ca 1930.

Harmonies: Intérieurs de Ruhlmann, nos. 17 and 38. Paris: Editions Albert Morancé, 1924.

Intérieurs, no. 39 from Portfolio II, 1924, and no. 42 from Portfolio IV, 1926. Paris: Editions Albert Lévy.

Intérieurs en coleurs, France (exposition des arts décoratifs, Paris, 1925), nos. 26, 33, 40, 45, and 51. Paris: Editions Albert Lévy, 1926.

Intérieurs français, nos. 10, 13, 41, 56, 57. Paris: Editions Albert Morancé, 1925.

BIOGRAPHICAL NOTES

No information was available for some designers.

Adnet, Jean and Jacques. Jacques Adnet (1900–1984) considered himself to be the champion of a "tradition that tended toward the future." Jean was his twin brother. They showed together at the salons beginning in 1923. From 1922 Jacques worked at la Maîtrise, the studio of Galeries Lafayette. Jean was made director of display there in 1928.

Atelier Martine. Founded by Paul Poiret (1879–1944) in 1911, the Atelier took an "experimental approach" (influenced, for example, by Cubism) to the creation of fabric and furniture, which was soon much in demand. A London branch was opened in 1924.

Chareau, Pierre (1883–1950). An architect, Chareau first showed at the Salon of 1919 and was one of the first to seek logical solutions to children's rooms, kitchens, and bathrooms. He collaborated with Mallet-Stevens and was cofounder of the Union des artistes modernes. Although he usually worked in fine hand-crafted materials, his interiors were Cubist in feeling. In 1926 he received the medal of the Légion d'honneur for advanced design.

Djo-Bourgeois, Edouard-Joseph (1898–1937). An architect, Djo-Bourgeois believed in obtaining maximum free space, which he achieved by built-in furniture and straight lines relieved by vivid color and the textiles designed by his wife, Elise George. He was one of the founders of the Union des artistes modernes.

Dominique. This firm, founded by André Domin

(1883–1962) and Marcel Genevrière (1885–1967), existed from 1922 to 1970. Beginning with the 1922 Salon, the firm was considered avant-garde for its use of geometric forms. It participated in the 1925 exhibition and in the decoration of the ocean liner the *Normandie*.

Dufet, Michel (1888–1985) and **Bureau, Louis.** In 1913 Dufet established the studio Mobilier artistique moderne, which produced furniture, fabrics, and lighting fixtures.

Dufrène, Maurice (1876–1955) and **Englinger, Gabriel (1898–?).** Reacting against the "excesses" of Art Nouveau, Dufrène cofounded the Société des artistes décorateurs, which employed "spare ornamentation." He designed film sets and taught (1912–13) at Ecole Boulle, Paris. From 1921 to 1952 Dufrène was the director of la Maîtrise, the influential design studio of the Galeries Lafayette. Englinger studied at Ecole Boulle and also worked at la Maîtrise.

Fréchet, André (1875–1973). Fréchet was editor of *Mobilier et décoration*. With his brother Paul he designed furniture for numerous firms. He taught design at the Ecole des beaux-arts in Nantes and at Ecole Boulle in Paris.

Gabriel, René (1890–1950). Gabriel designed hand-blocked wallpaper using floral landscapes and abstract designs. Late in his career he designed simple rectilinear oak unit furniture.

Guévrékian, Gabriel (1900–1970). Originally from Istanbul, Guévrékian went to Paris in 1921 after studying architecture in Vienna. He started working for Mallet-Stevens in 1922 and established his own business in 1926. He was a member of the Union des artistes modernes and worked in America and Asia as well as in Europe.

Jallot, Léon (1874–1967). An independent designer of interiors and textiles, Jallot also did illustrations for *Art et décoration*.

Joubert, René (died 1931) and **Petit, Philippe (1900–1945).** In 1914 Joubert established, with Georges Mouveau, the firm Décoration intérieur moderne in Paris. Their work was prominently displayed at the 1925 exhibition.

Jourdain, Francis (1876–1958). Originally a painter, Jourdain became interested in the problems of modern interior design. He was the first to confront the problem of increasingly restricted space by removing furniture rather than adding it. He founded les Ateliers modernes in 1912. Feeling that the Société had ceased to fulfill its mission to provide good design to a wide public, he left to join the Union des artistes modernes in 1929.

Kohlmann, Etienne (born 1903). As director of the Studium from 1923 to 1938, Kohlmann adapted modern geometric qualities for the clients of Grands magasins du Louvre. Working with his codirector, Maurice Matet, he made modern design available to a large public at a reasonable price.

Lurçat, André (1894–1970). Lurçat was one of the major Parisian architects of the 1920s. He was also a designer of tubular furniture for the firm Thonet. He wrote *Architecture* (1929) and the influential five-volume work *Formes, composition et lois d'harmonie* (1933–37).

Mallet-Stevens, Robert (1886–1945). Mallet-Stevens's career as an architect and decorator began in 1913. The modernism of his designs was moderated by beautiful materials and attention to detail. He was among the first to use metal and tubular steel for chairs. He was the first president of the Union des artistes modernes.

Matet, Maurice (1903–1989). Matet first worked with Etienne Kohlmann at the Studium and left to teach at l'Ecole des arts appliqués.

Moreux, Jean-Claude (1889–1958). An architect, Moreux sought a middle ground between the extremes of design by being both modern and classic.

Ruhlmann, Jacques-Emile (1879–1933). Known for his use of exquisite materials and fine craftsmanship, Ruhlmann worked for a clientele seeking luxury design. Called the "Riesener of 1925" in reference to the eighteenth-century cabinetmaker employed by Marie Antoinette, he created extraordinary designs that combined a modern look with the long tradition of fine French furniture making. Only at the end of his career did he begin to use steel and glass in his designs.

Sognot, Louis (1892–1970). In 1920 Sognot worked for Primavera, the studio at le Printemps department store, as codirector with Mme. Chauchet-Guillère. From 1929 he worked with metal and glass in a functional but decorative style.

INDEX OF DESIGNERS

Adnet, Jean and Jacques, 70, 71, 78
Atelier Martine, 10, 41
Chareau, Pierre, 11, 56
Dalmas, Marcel, 45
Delacroix, Henry, 31
Djo-Bourgeois, Edouard-Joseph, 4, 5, 14, 15, 35, 53
Dominique, 18, 19
Dufet, Michel, and Bureau, Louis, 57
Dufrène, Maurice, 26
Englinger, Gabriel, 26
Fréchet, André, 40
Gabriel, René, 44, 51, 54
Ginsburger, 66, 72–74
Guévrékian, Gabriel, 22, 23, 46, 52

Jallot, Léon, 42
Joubert, René, and Petit, Philippe, 33, 39
Jourdain, Francis, 12, 13, 20, 21, 29, 65
Kohlmann, Etienne, 34, 43, 50, 60–64
Lézine, A., 30
Lurçat, André, 37
Mallet-Stevens, Robert, 49, 58, 59
Matet, Maurice, 6–9
Meistermann, Jacques, 2, 3
Moreux, Jean-Claude, 27, 32
Pommier, Robert, 47
Ruhlmann, Jacques-Emile, 16, 17, 38, 48, 79
Skolnik, Noémi, 36, 55, 67–69, 75–77
Sognot, Louis, 1, 24, 25, 28

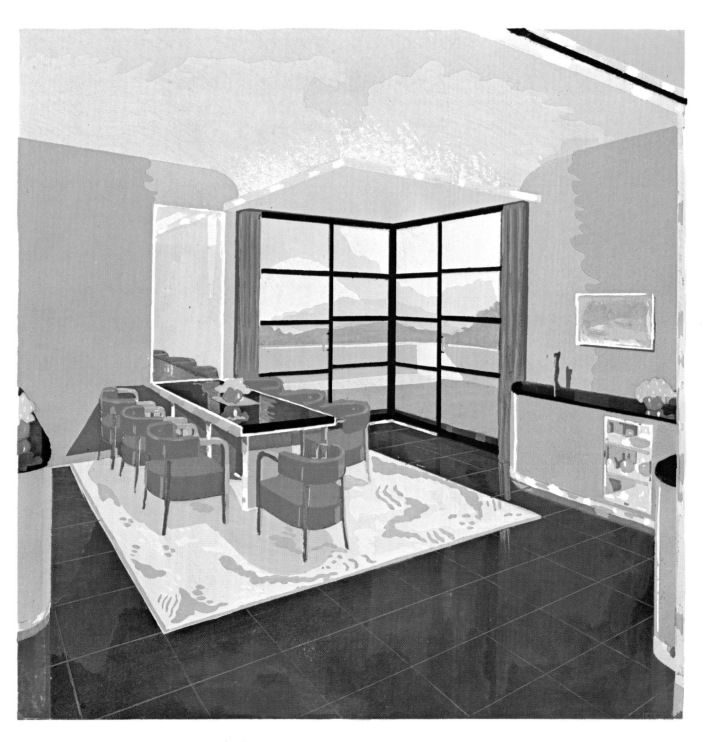

3. Dining room, by Jacques Meistermann

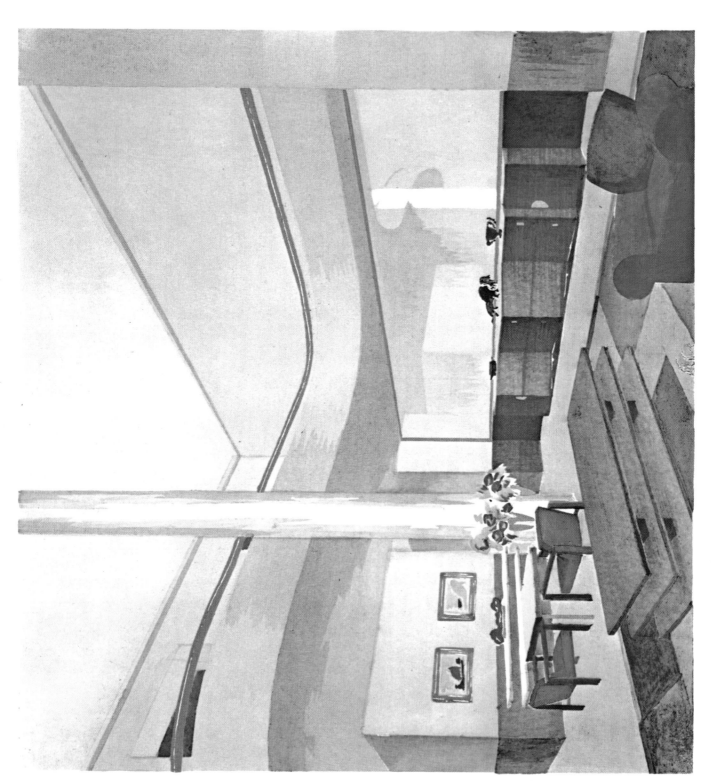

4. Living room, by Edouard-Joseph Djo-Bourgeois

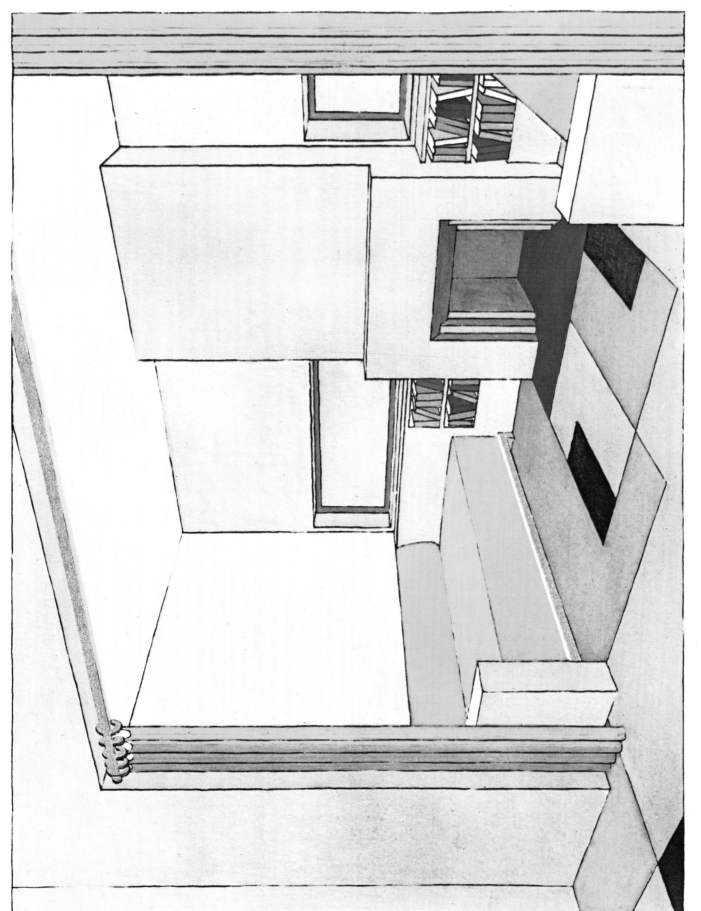

5. Living room fireplace, by Edouard-Joseph Djo-Bourgeois

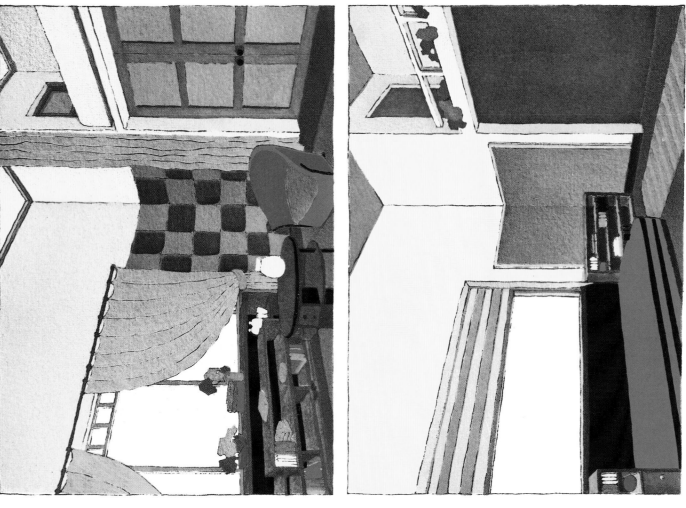

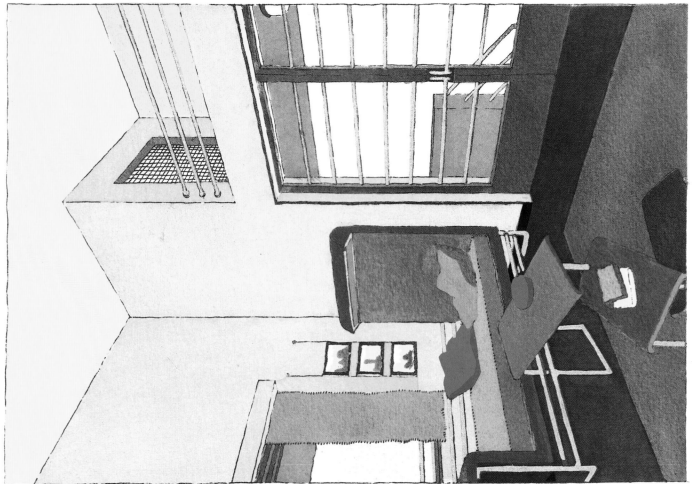

6. Details of atelier-studio, by Maurice Matet

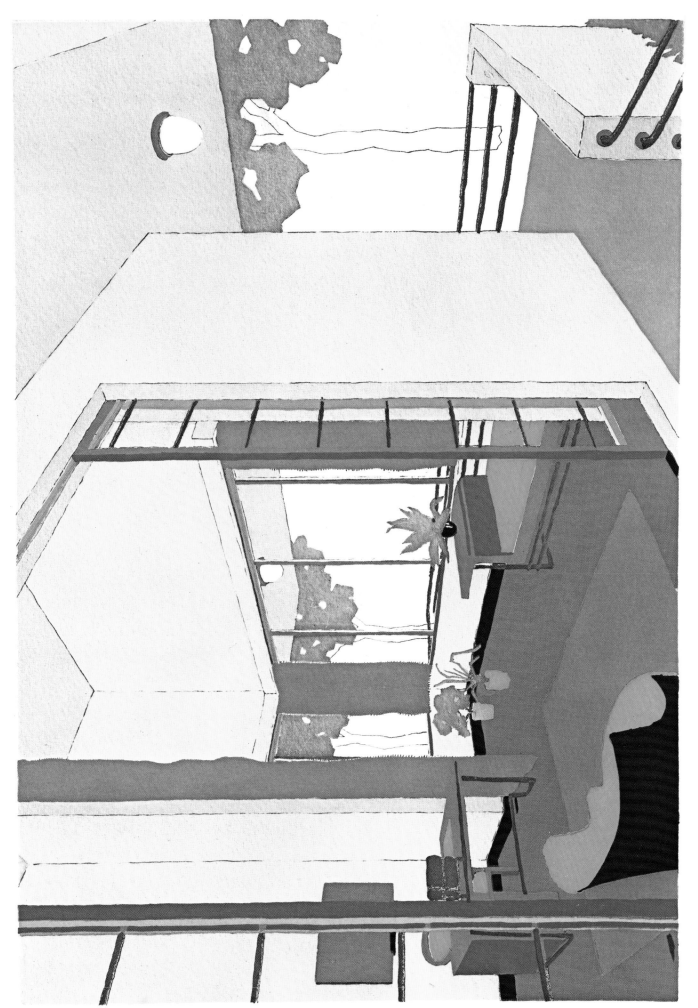

7. Atelier-studio, by Maurice Matet

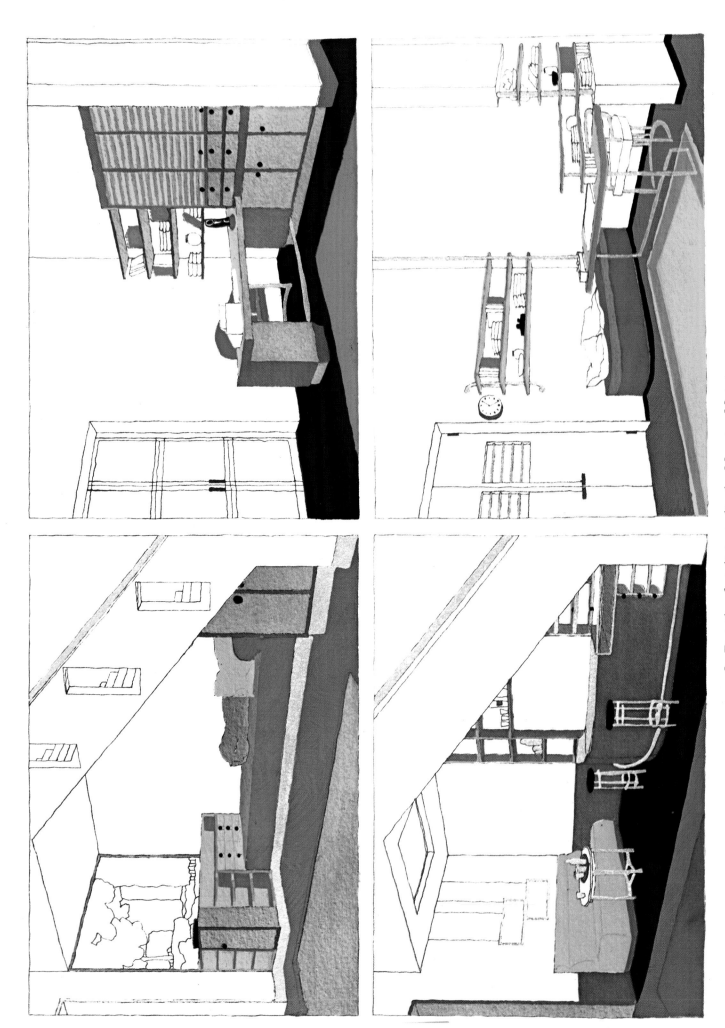

8. Details of atelier-studio, by Maurice Matet

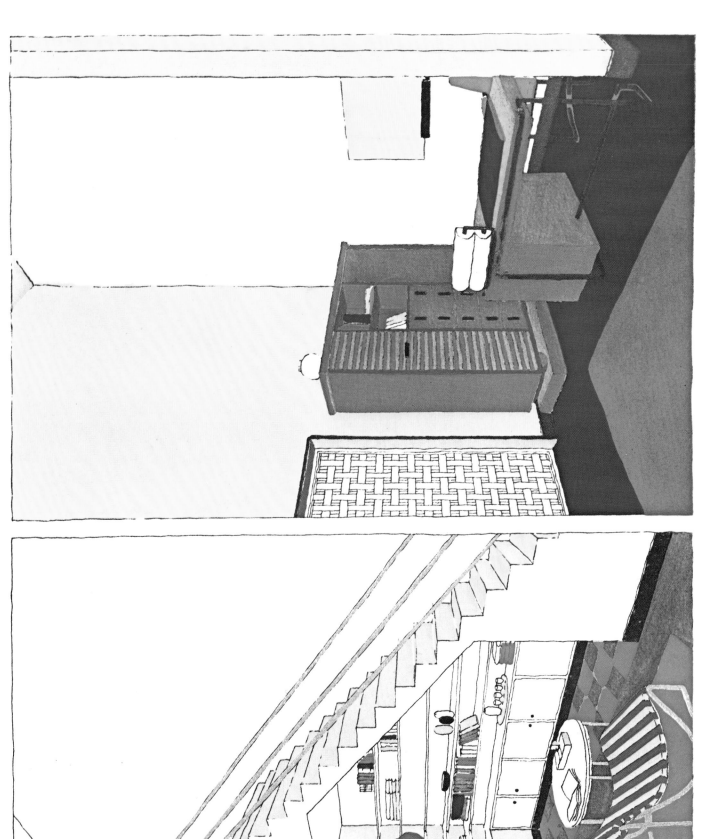

9. Details of atelier-studio, by Maurice Matet

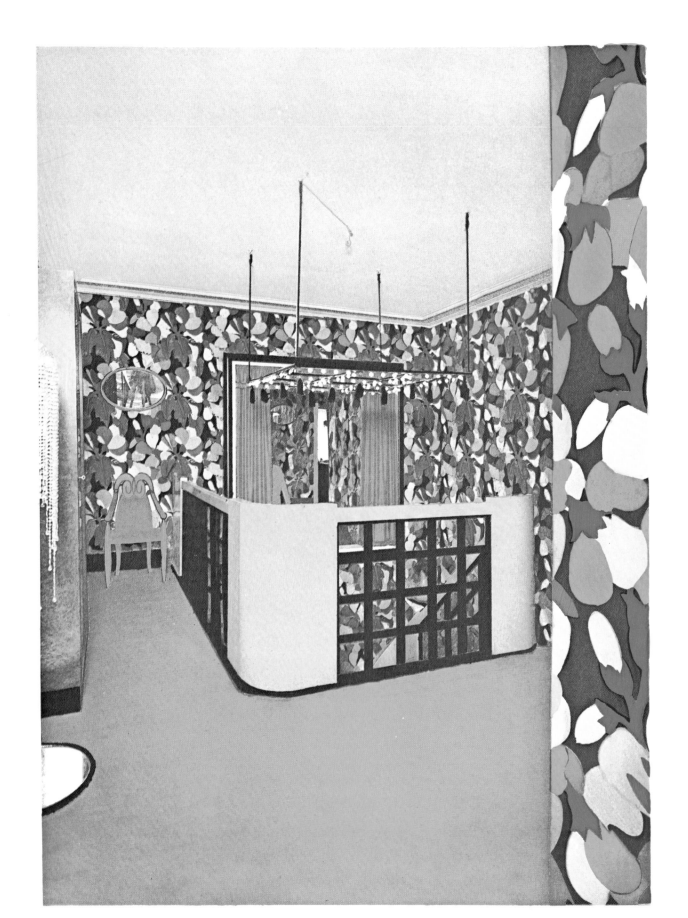

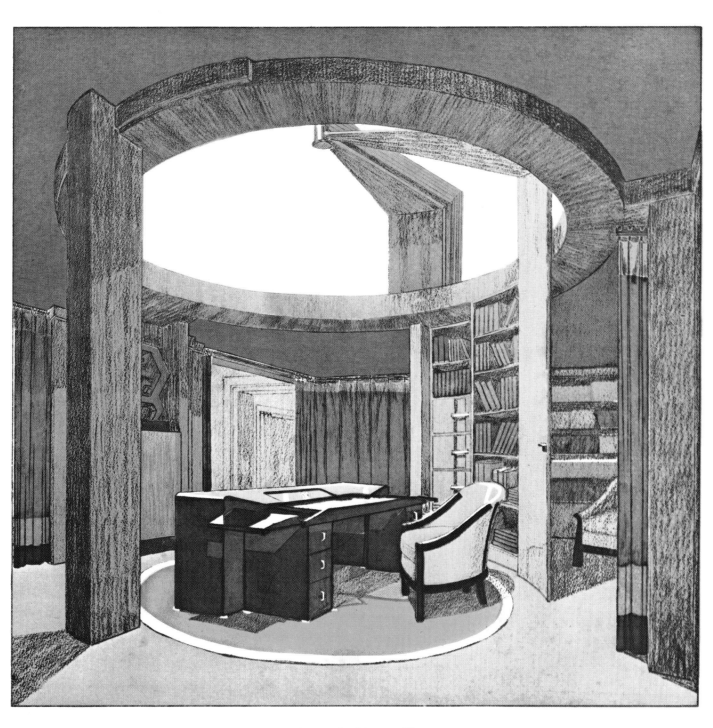

11. Library, by Pierre Chareau

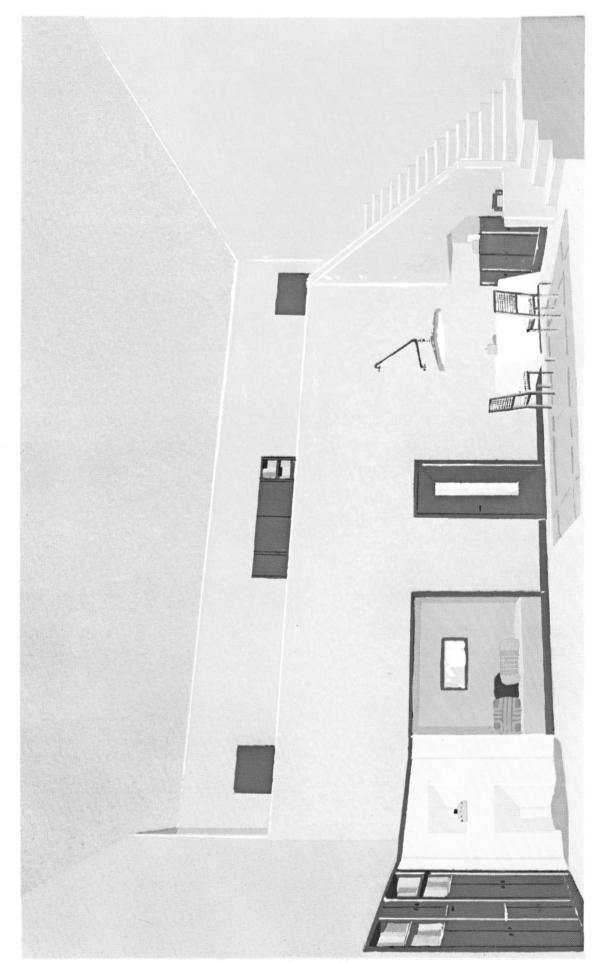

12. Living/dining area in a villa, by Francis Jourdain

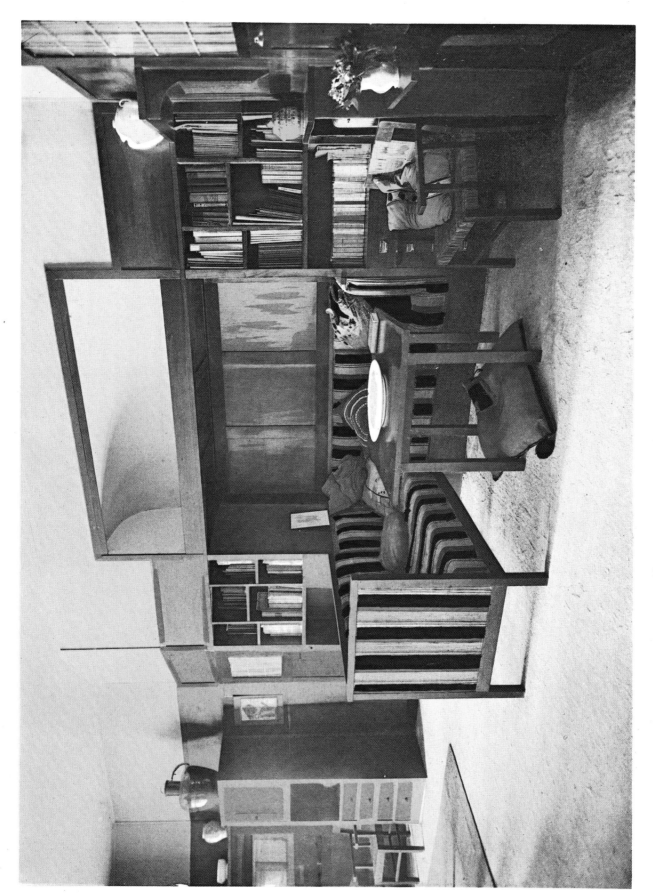

13. Living room, by Francis Jourdain

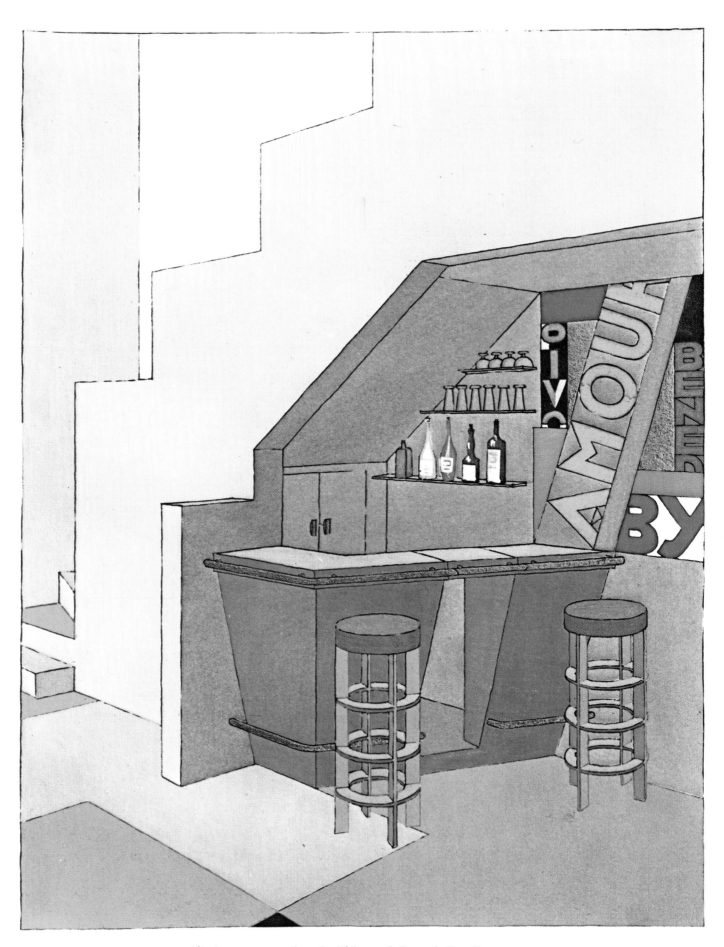

14. Living-room bar, by Edouard-Joseph Djo-Bourgeois

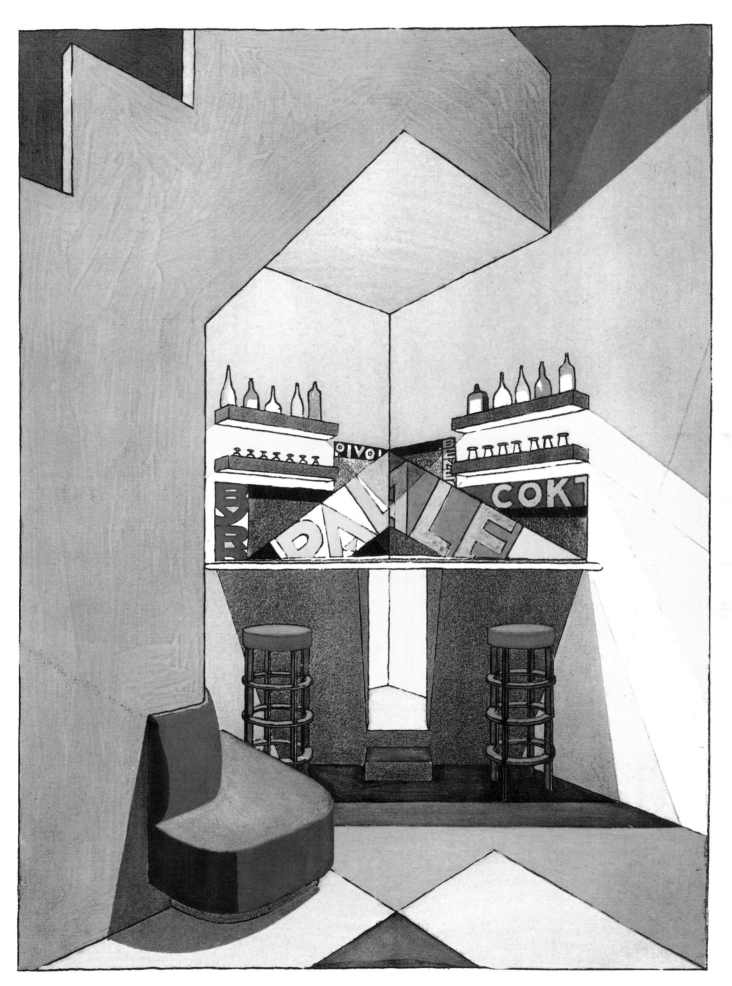

15. Living-room bar, by Edouard-Joseph Djo-Bourgeois

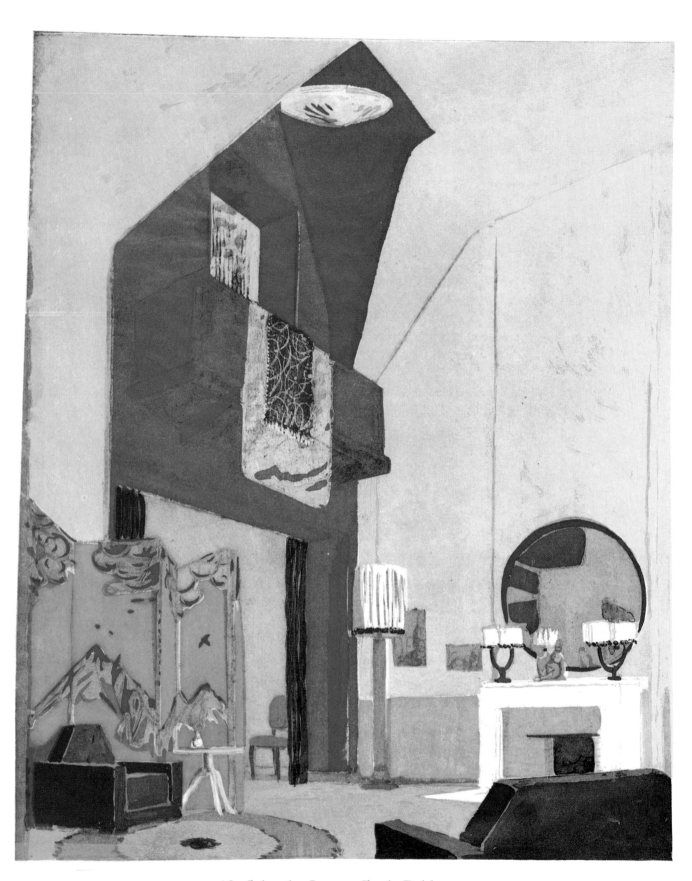

16. Salon, by Jacques-Emile Ruhlmann

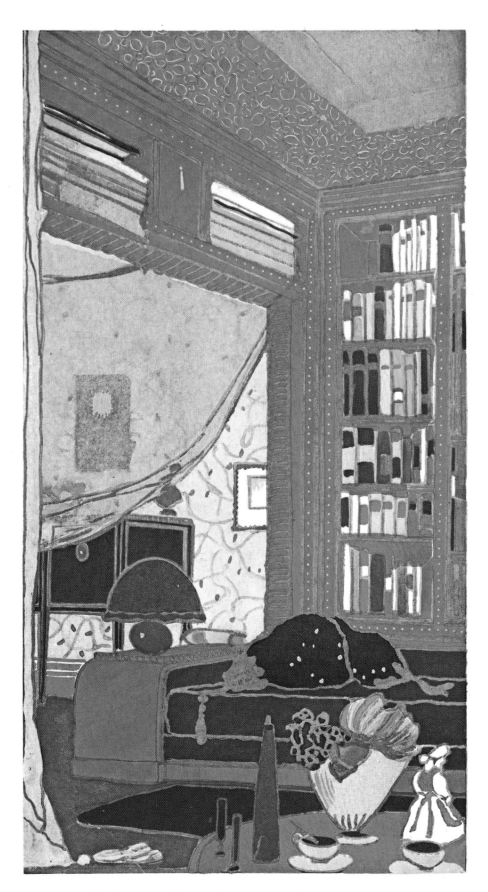

17. Boudoir-library, by Jacques-Emile Ruhlmann

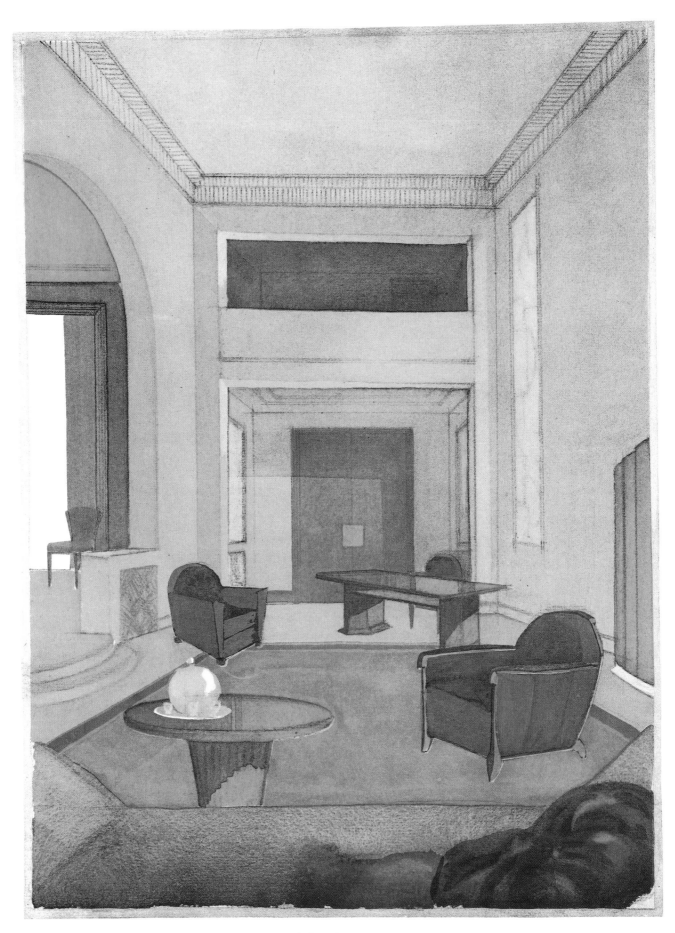

18. Salon, by Dominique

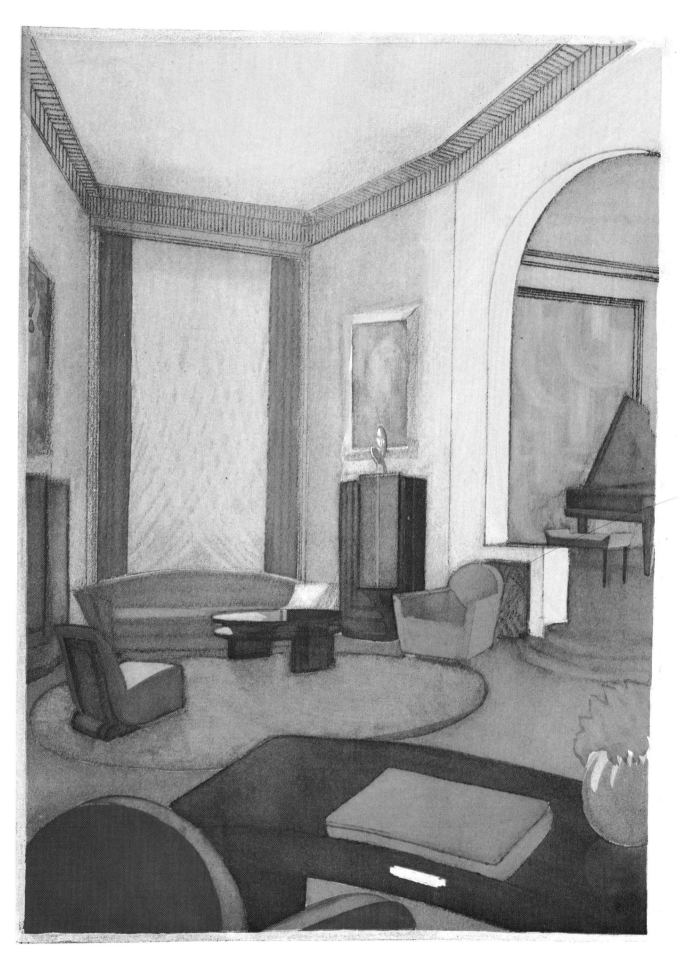

19. Salon, by Dominique

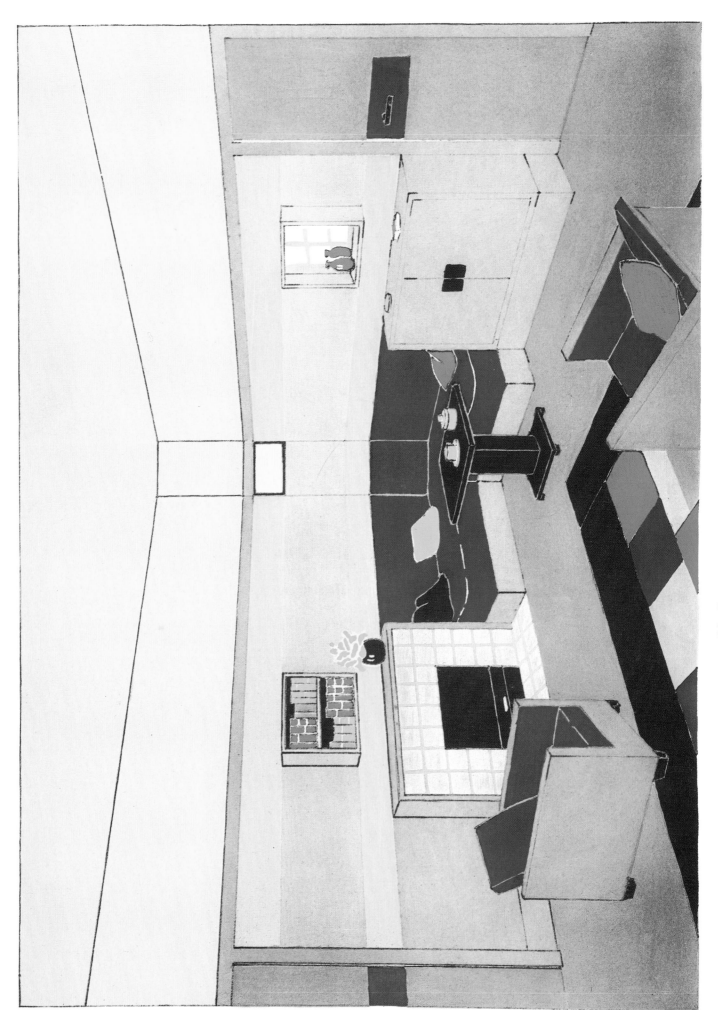

20. Living room, by Francis Jourdain

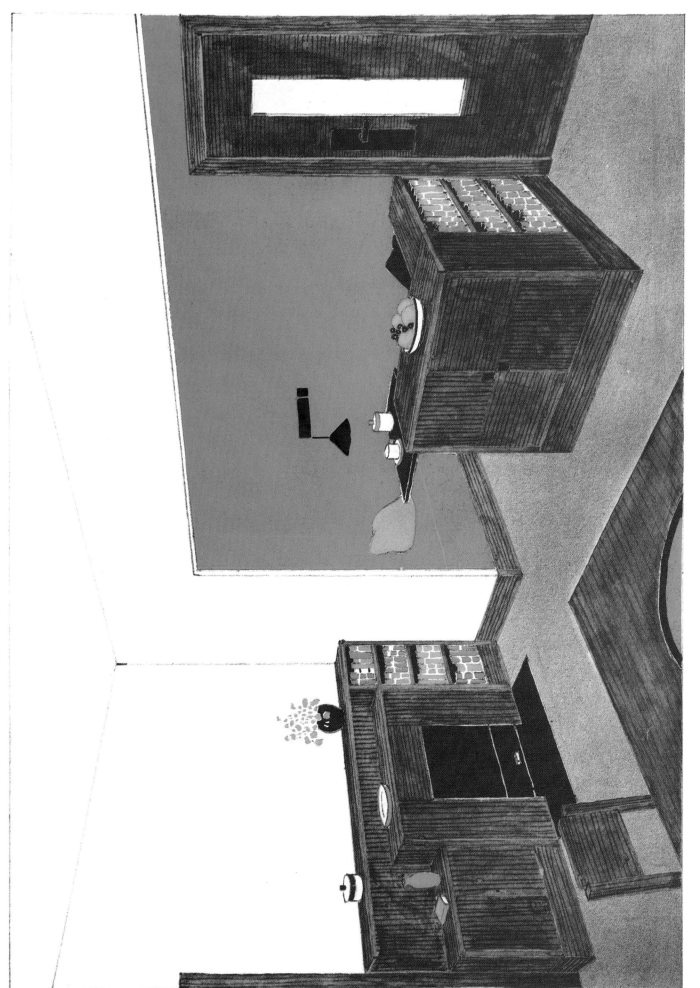

21. Living room, by Francis Jourdain

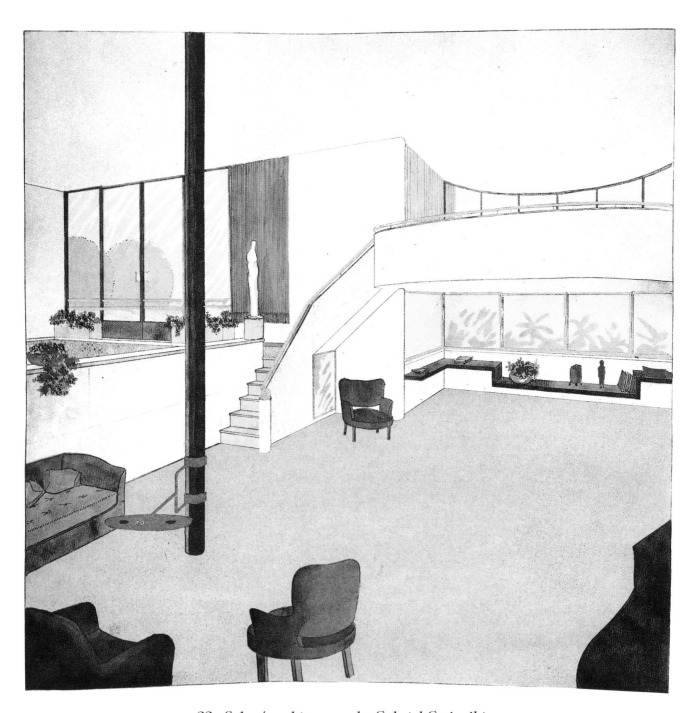

22. Salon/smoking area, by Gabriel Guévrékian

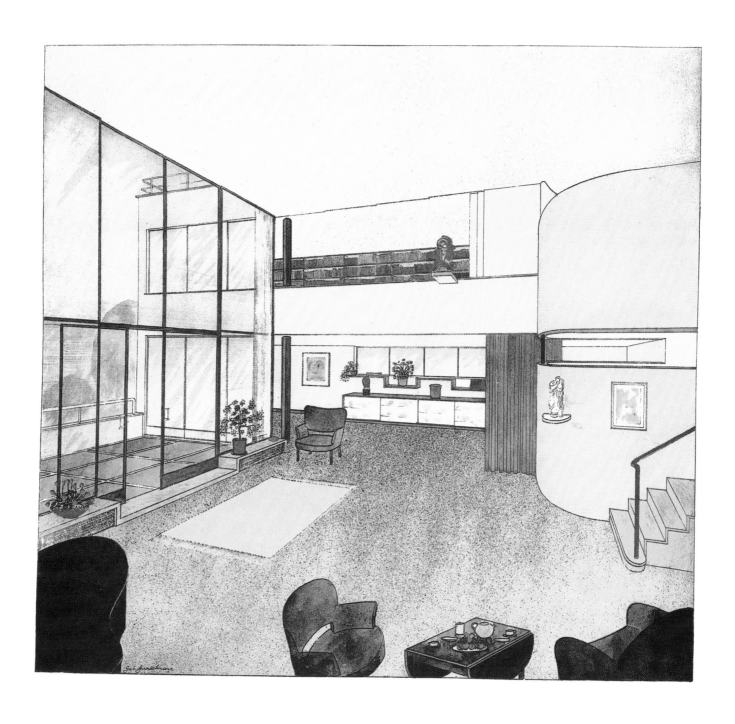

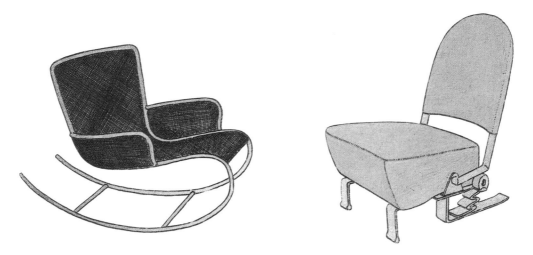

23. Entrance hall and chairs, by Gabriel Guévrékian

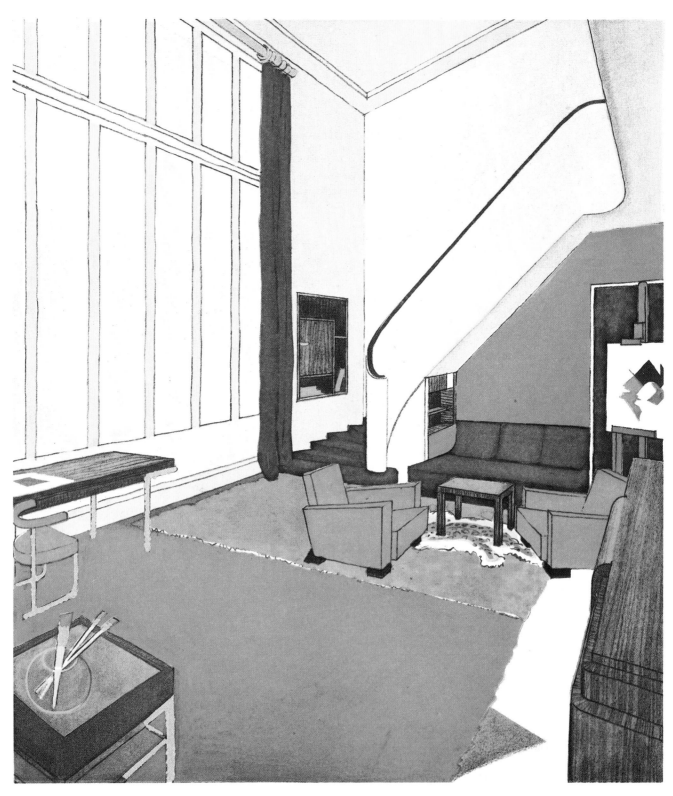

24. Atelier-studio, by Louis Sognot

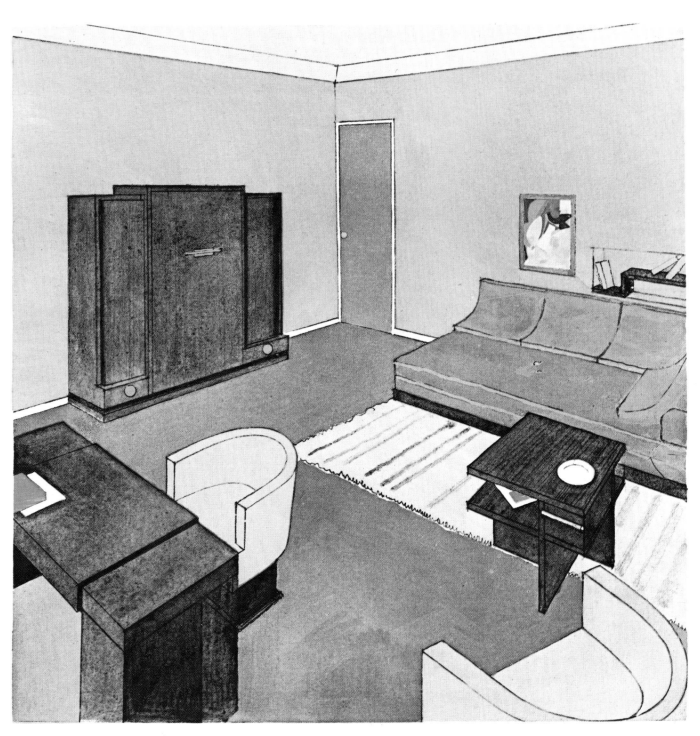

25. Studio apartment, by Louis Sognot

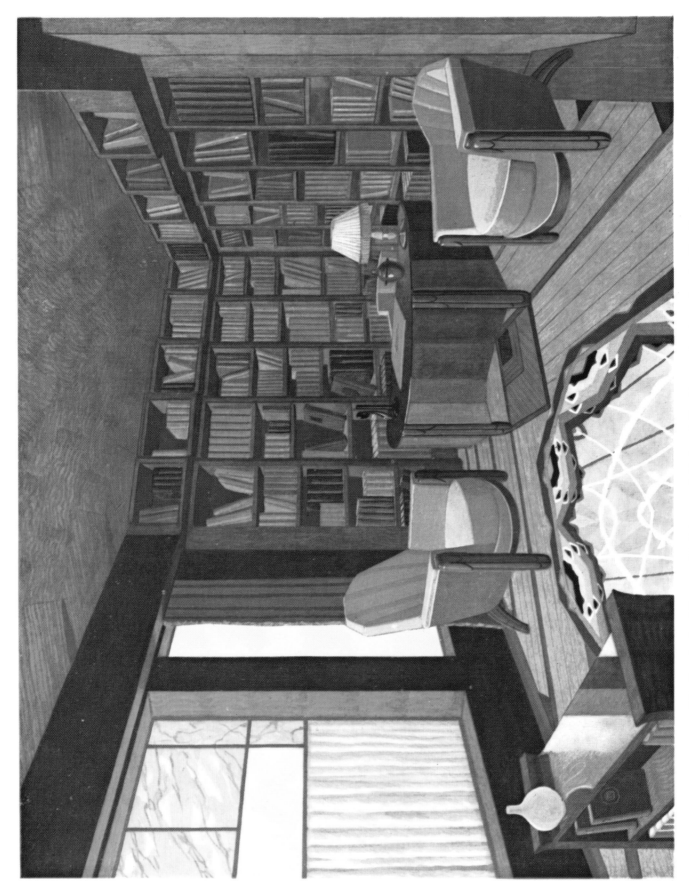

26. Study, by Maurice Dufrêne and Gabriel Englinger (watercolor by Englinger)

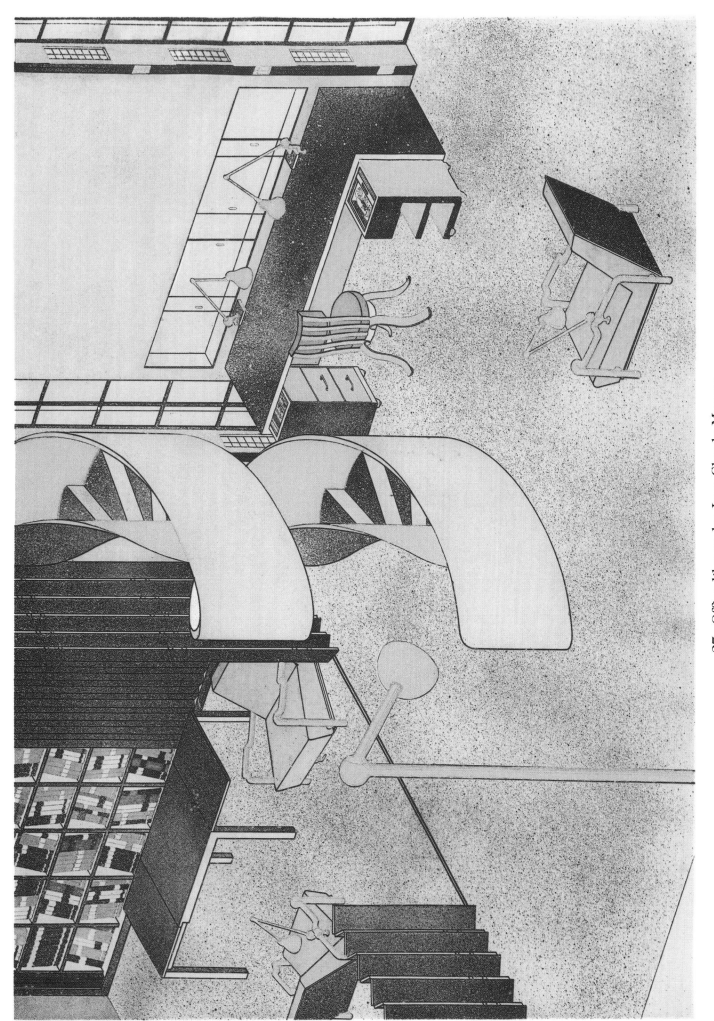

27. Office-library, by Jean-Claude Moreux

28. Atelier-studio, by Louis Sognot

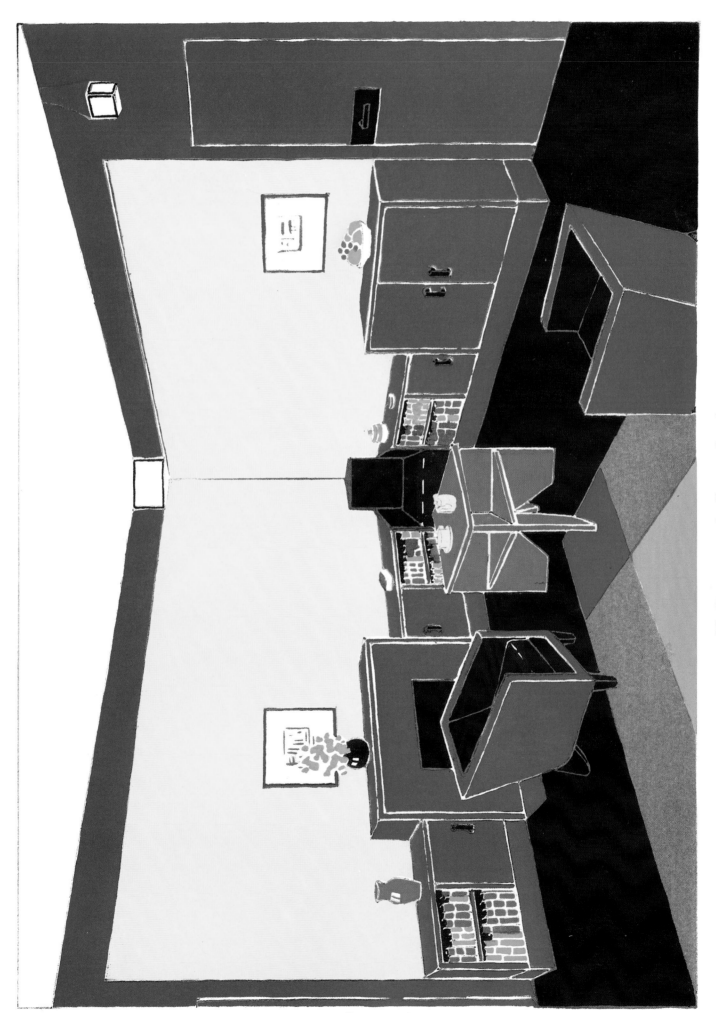

29. Living room, by Francis Jourdain

30. Study, by A. Lézine

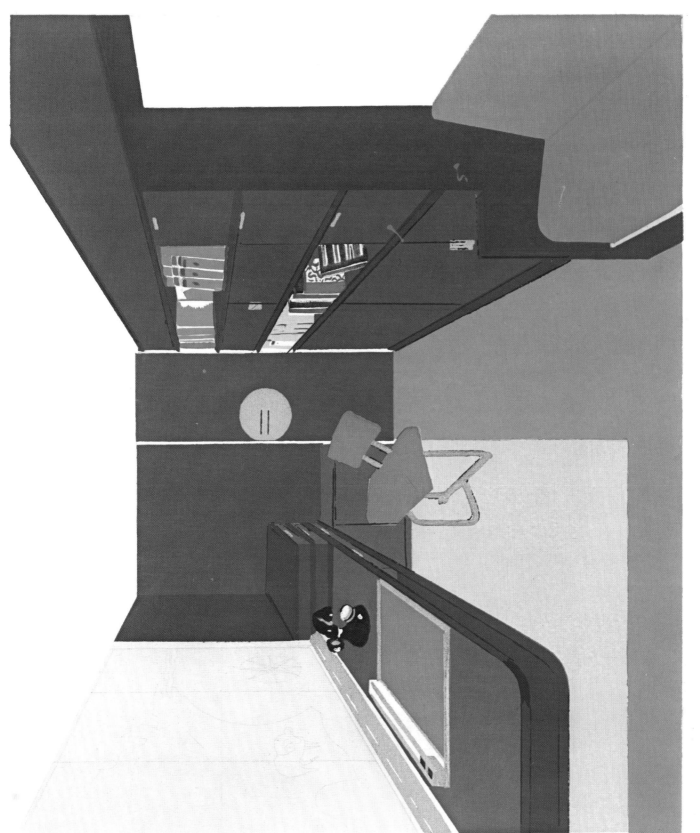

31. Study, by Henry Delacroix

32. Salon-library, by Jean-Claude Moreux

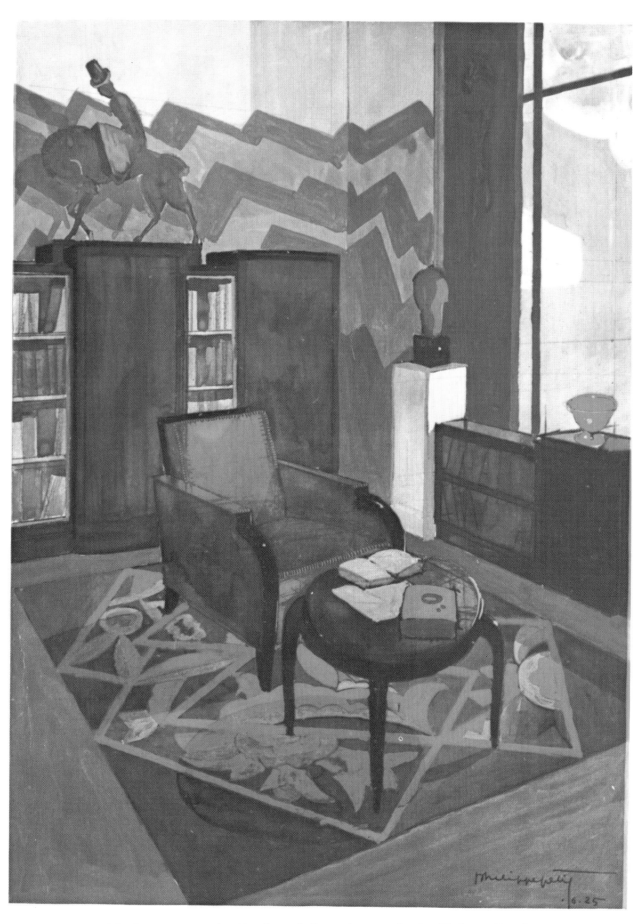

33. Living room, by Jourbert & Petit (watercolor by Philippe Petit)

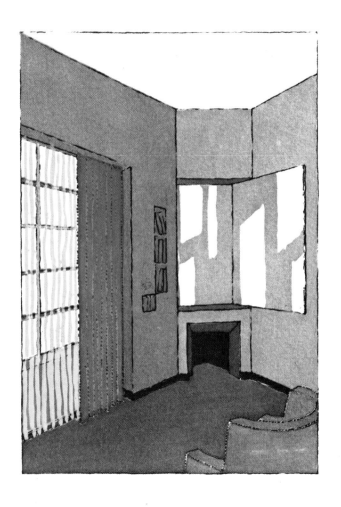
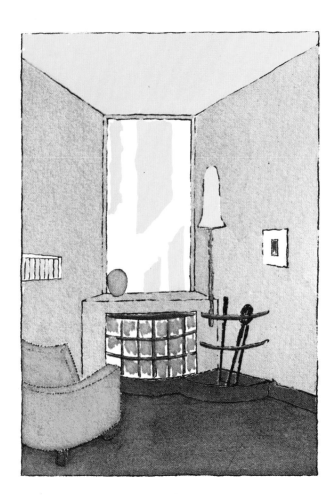
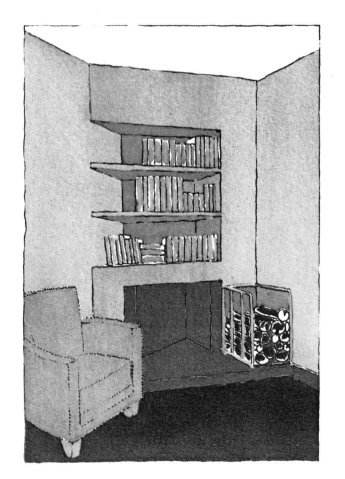
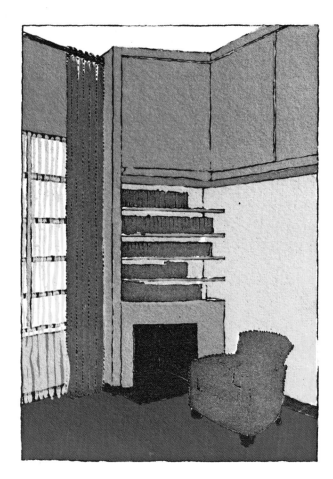

34. Dining-room corner fireplaces, by Etienne Kohlmann

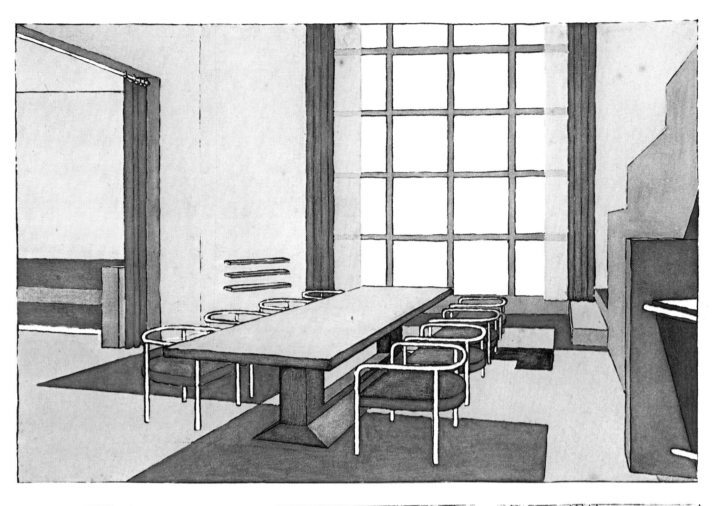

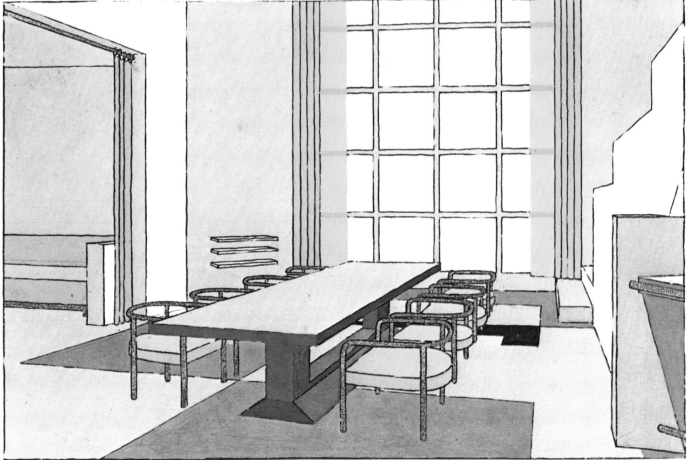

35. Living room, by Edouard-Joseph Djo-Bourgeois

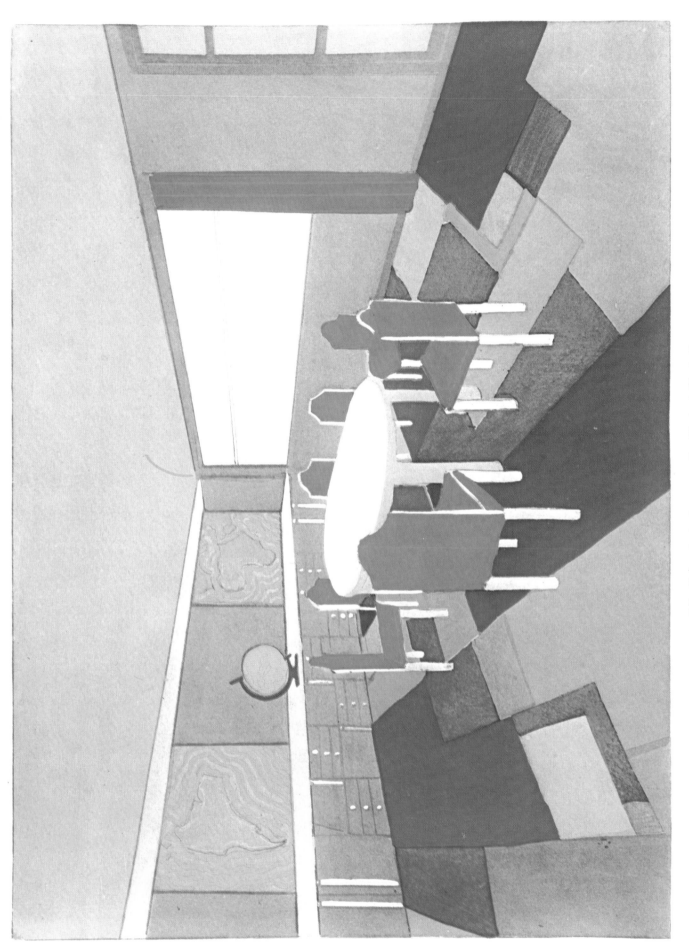

36. School study room, by Noémi Skolnik

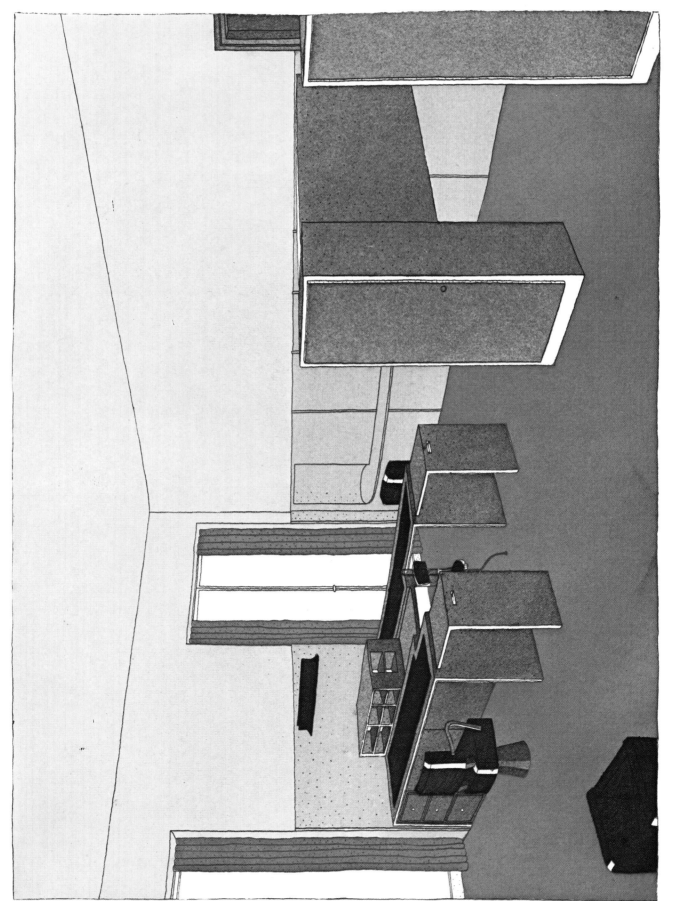

37. Office, by André Lurçat

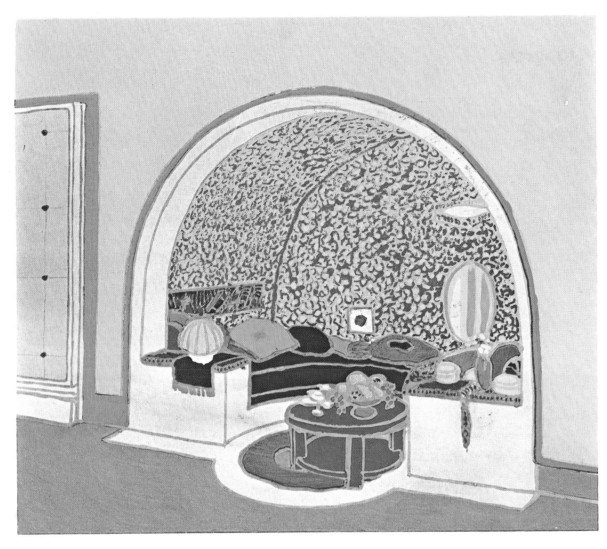

38. Niche, by Jacques-Emile Ruhlmann

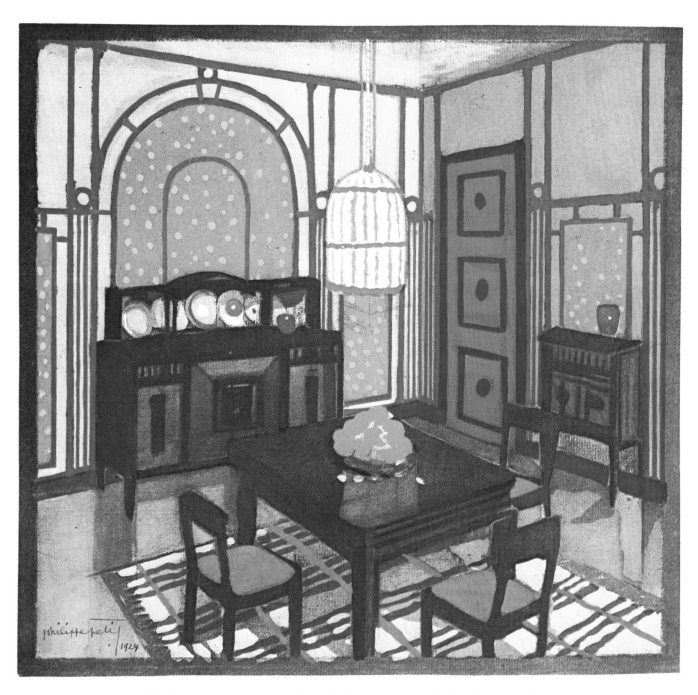

39. Dining room, by Joubert & Petit (watercolor by Philippe Petit)

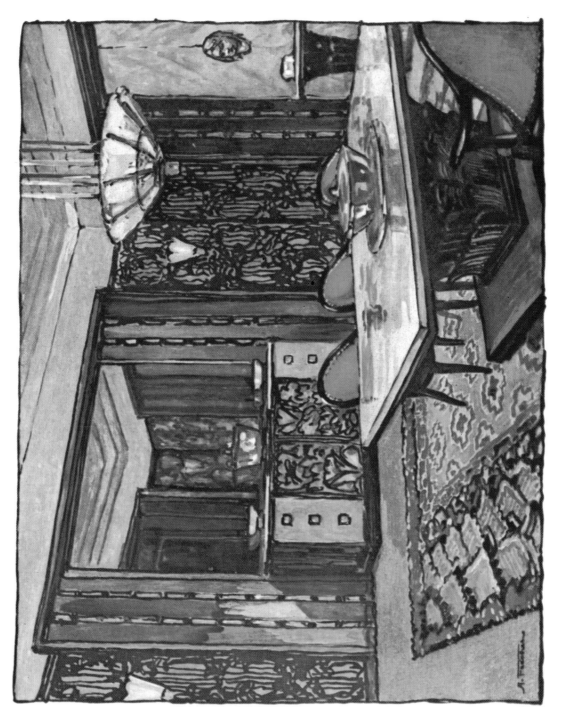

40. Dining room, by André Fréchet

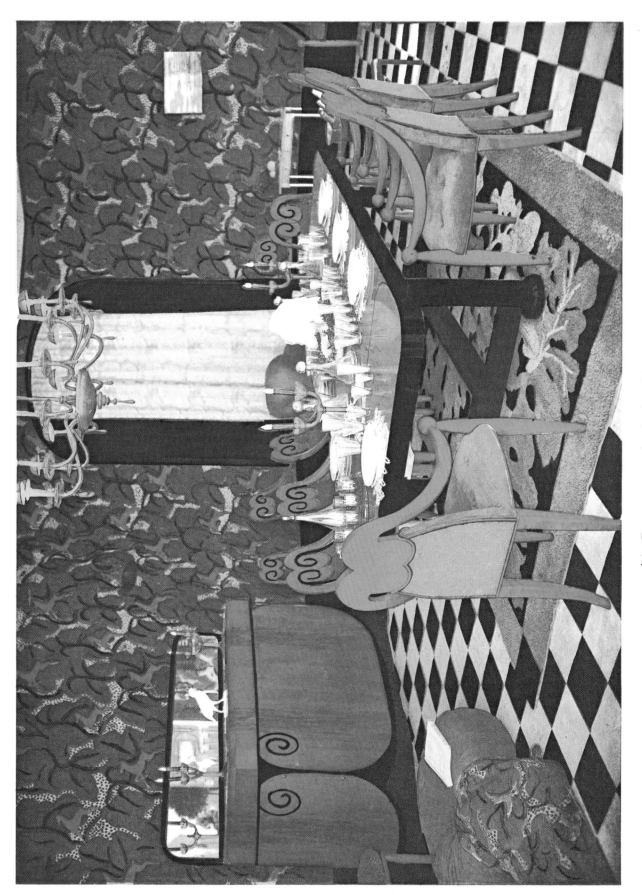

41. Dining room, by Atelier Martine

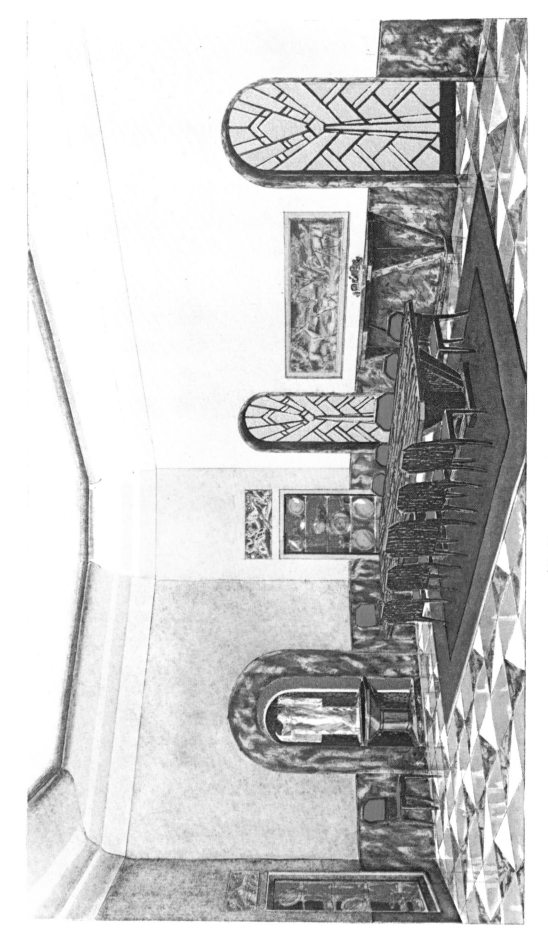

42. Dining room by Léon Jallot

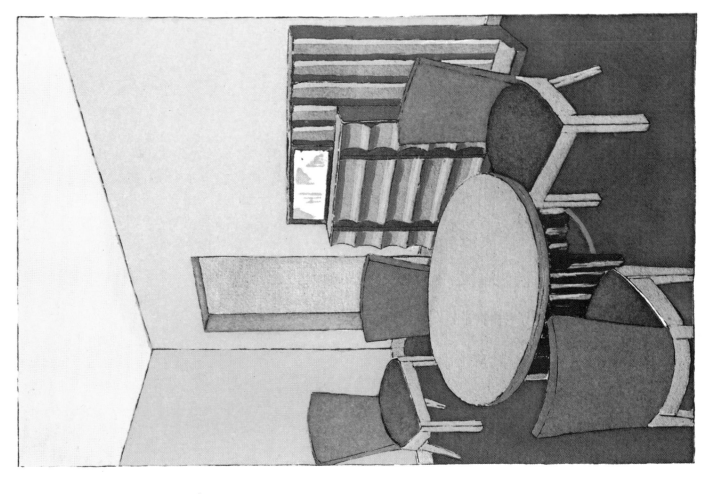

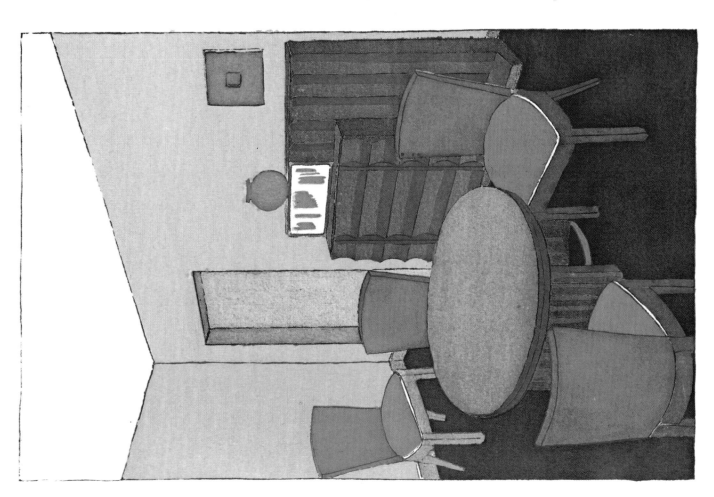

43. Dining room, by Etienne Kohlmann

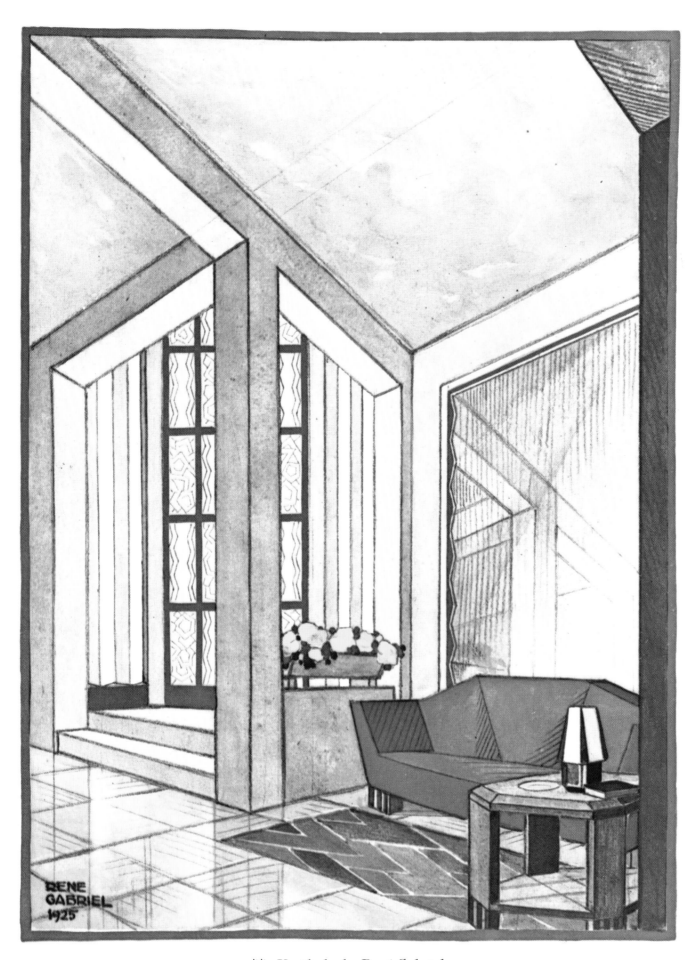

44. Vestibule, by René Gabriel

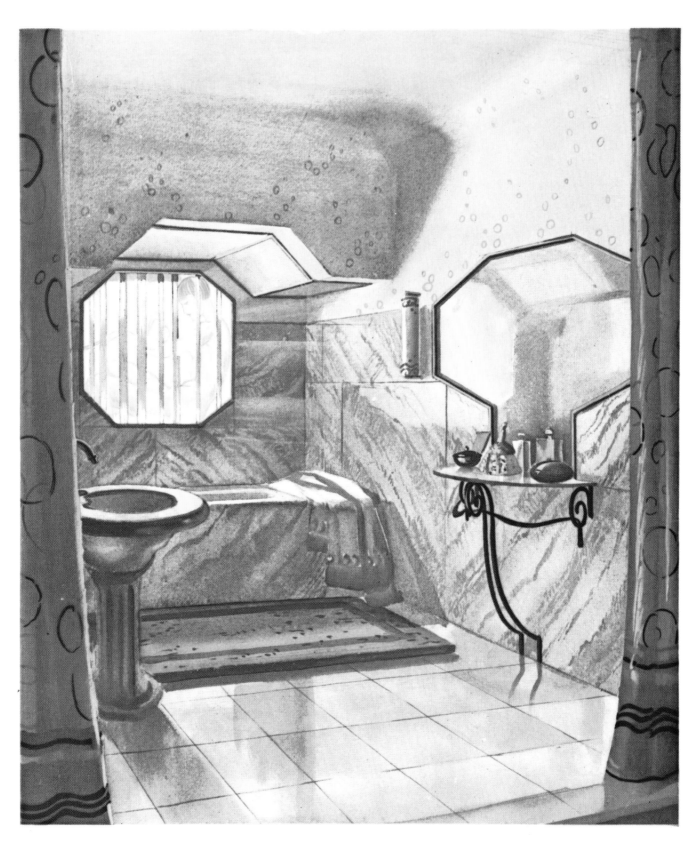

45. Bathroom, by Marcel Dalmas (watercolor by Libis)

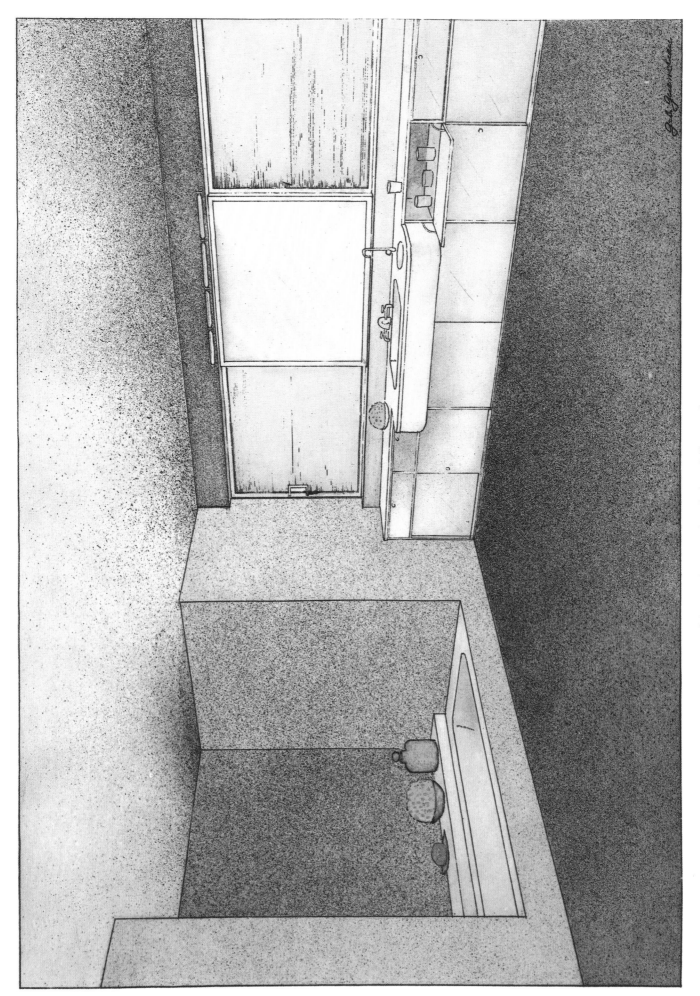

46. Bathroom, by Gabriel Guévrékian

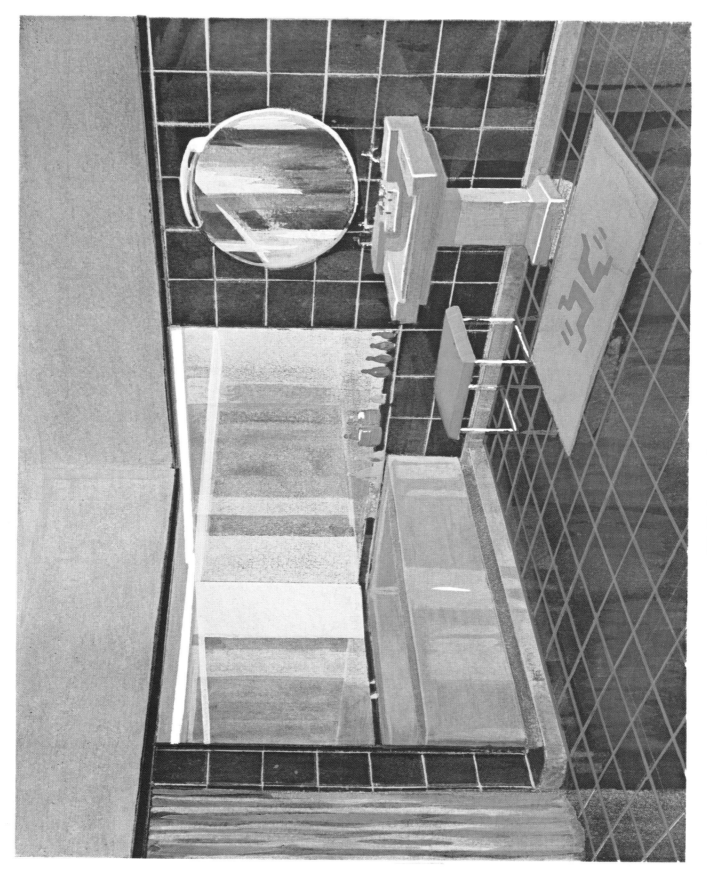

47. Bathroom, by Robert Pommier

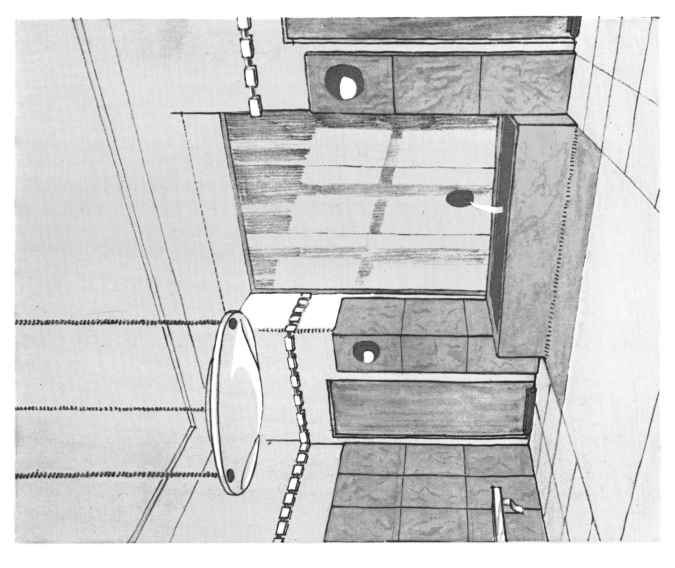

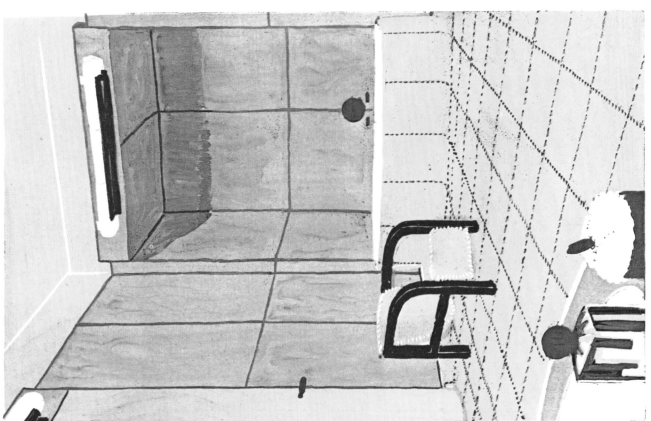

48. Bathrooms, by Jacques-Émile Ruhlmann

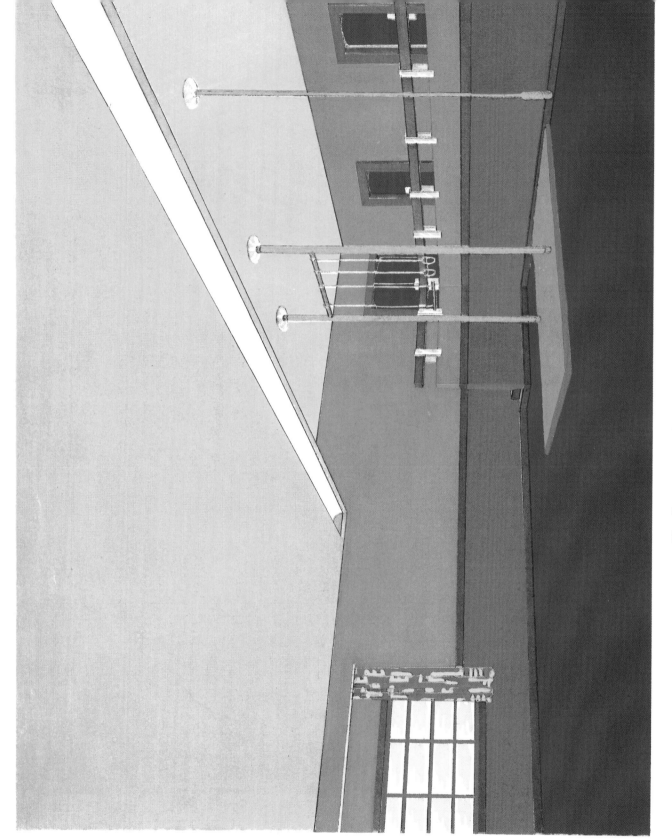

49. Gymnasium, by Robert Mallet-Stevens

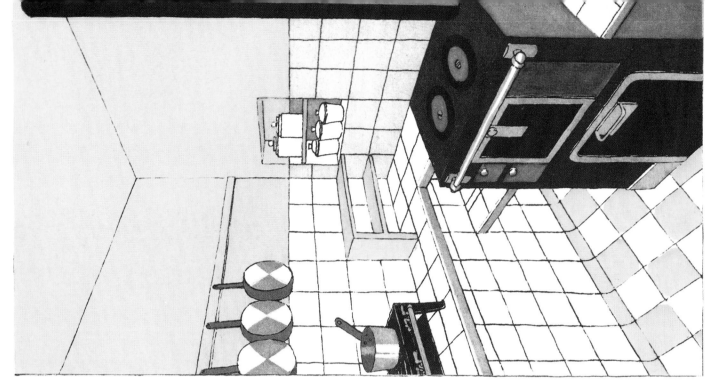

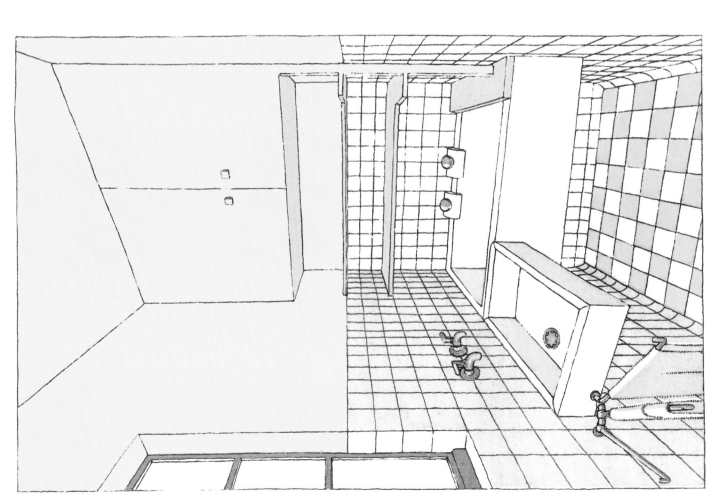

50. Kitchens, by Etienne Kohlmann

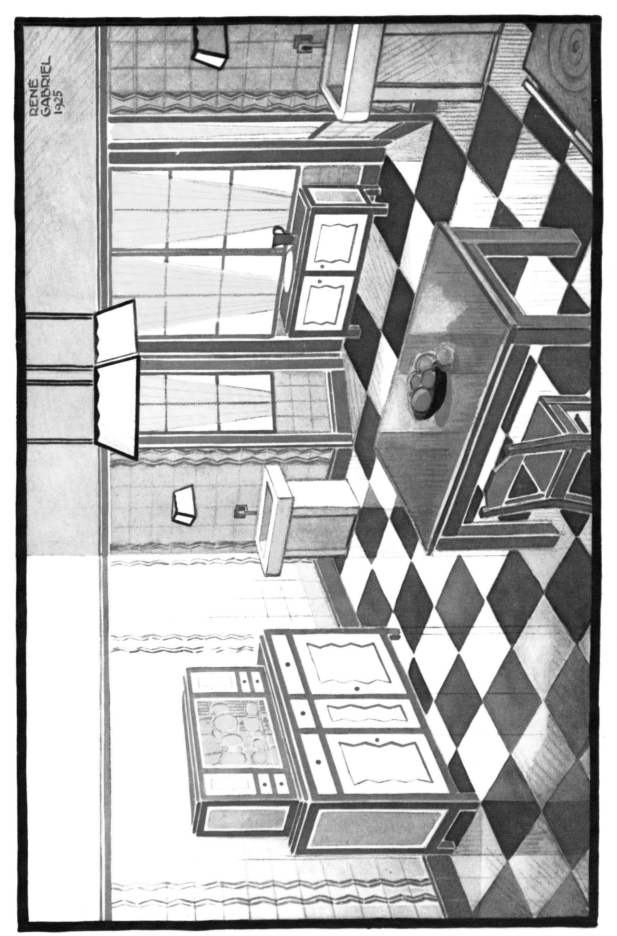

51. Kitchen, by René Gabriel

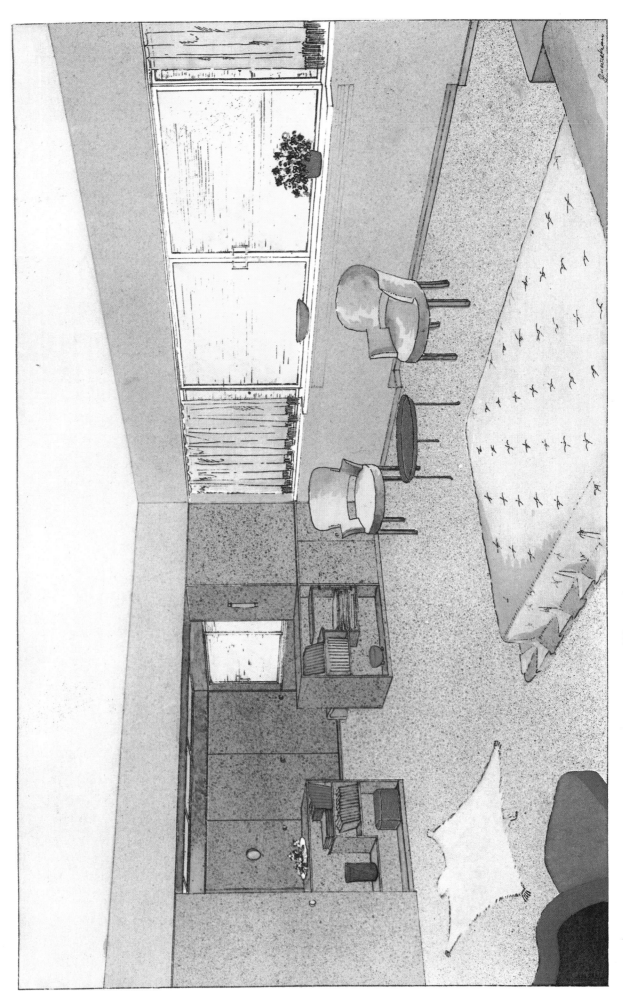

52. Lady's bedroom, by Gabriel Guévrékian

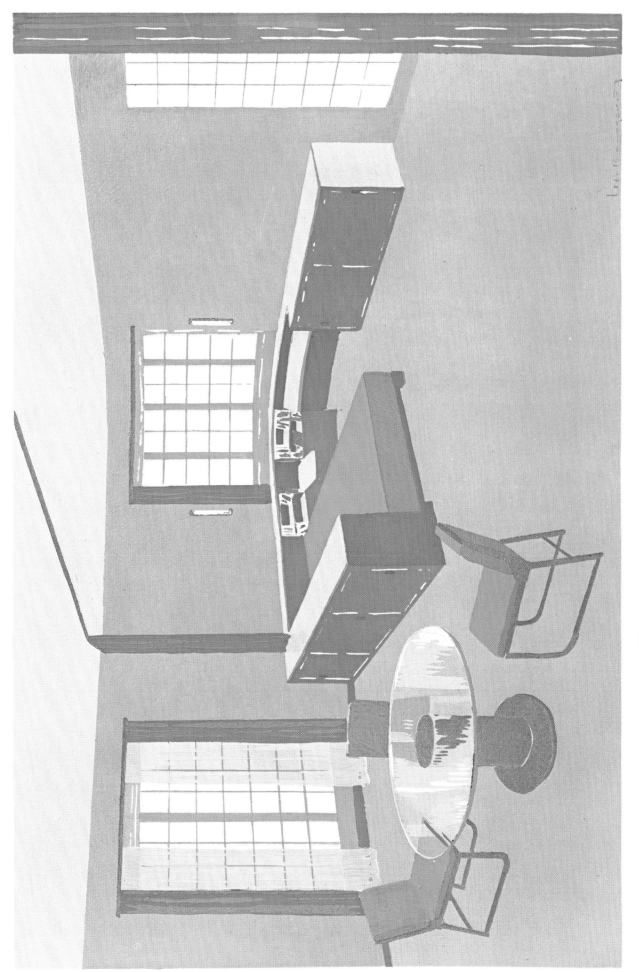

53. Bedroom, by Edouard-Joseph Djo-Bourgeois

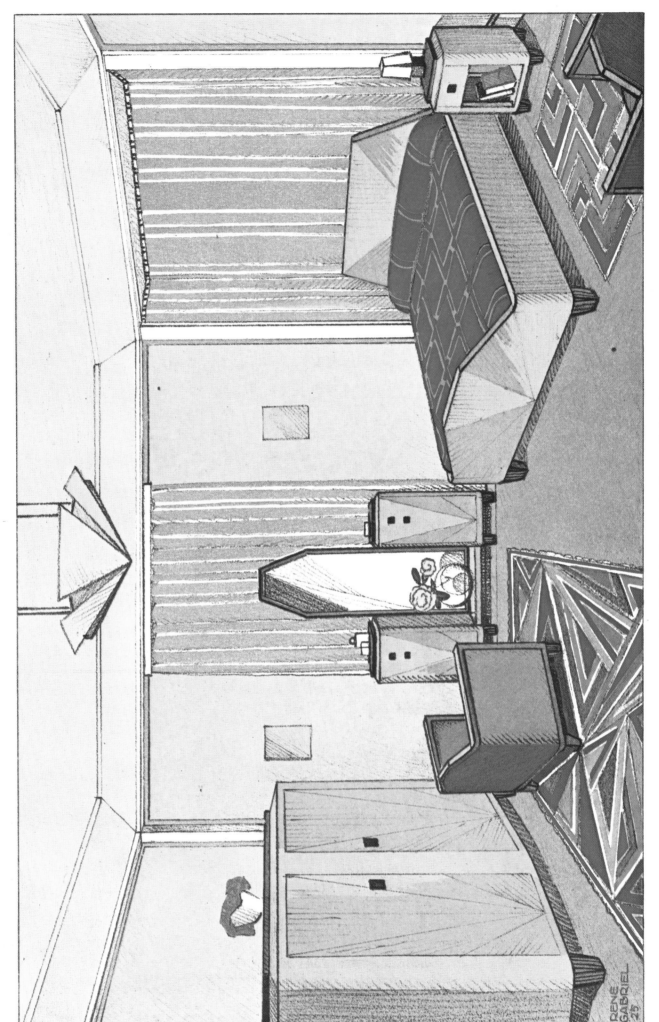

54. Girl's bedroom, by René Gabriel

55. Bedroom, by Noémi Skolnik

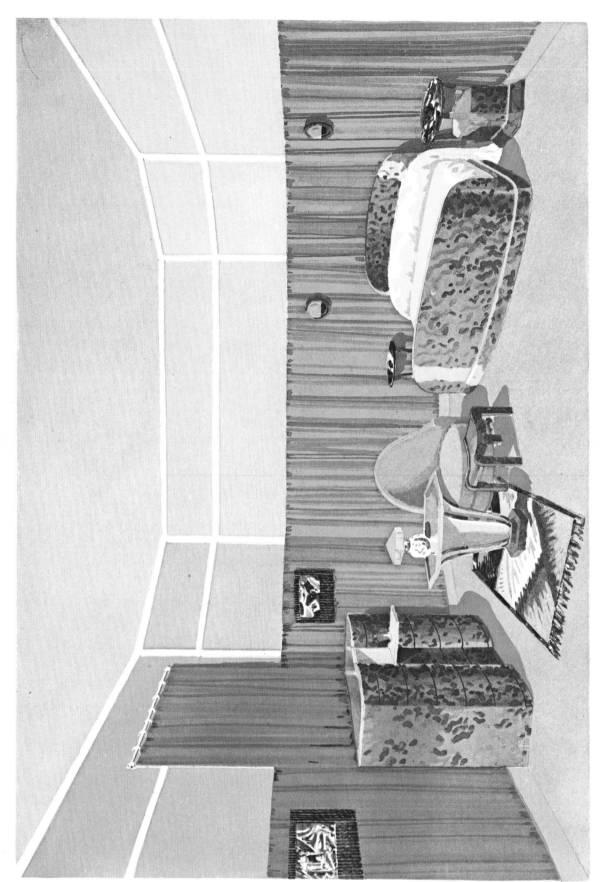

56. Bedroom, by Pierre Chareau

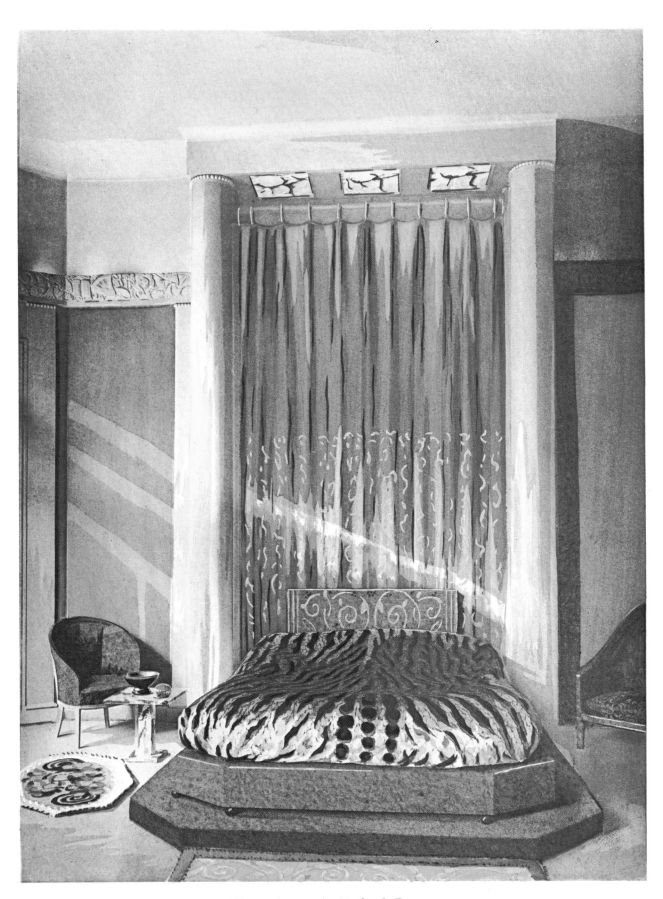

57. Bedroom, by Dufet & Bureau

58. Bedroom, by Robert Mallet-Stevens

59. Bedroom, by Robert Mallet-Stevens

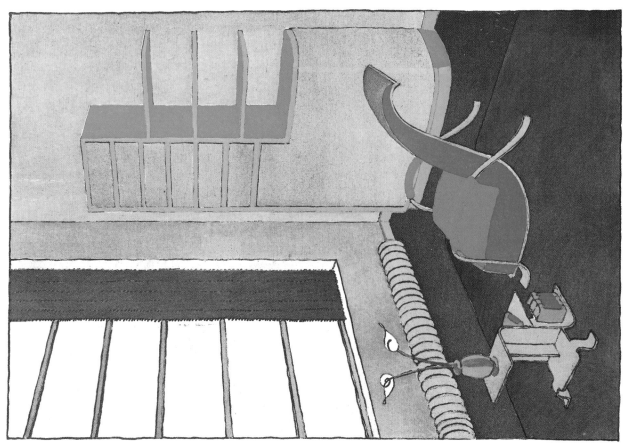

60. Details of man's room, by Etienne Kohlmann

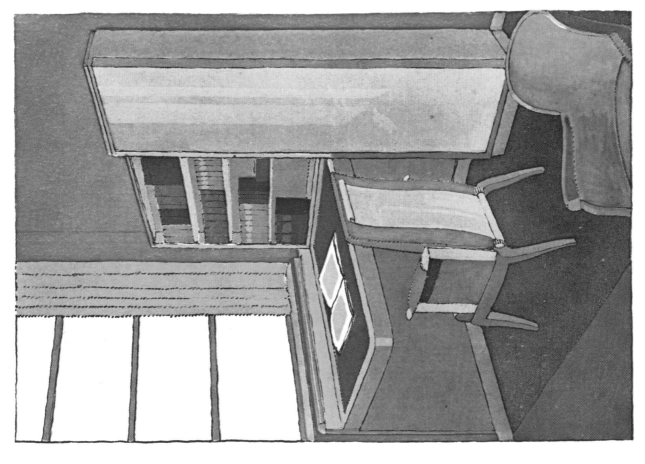

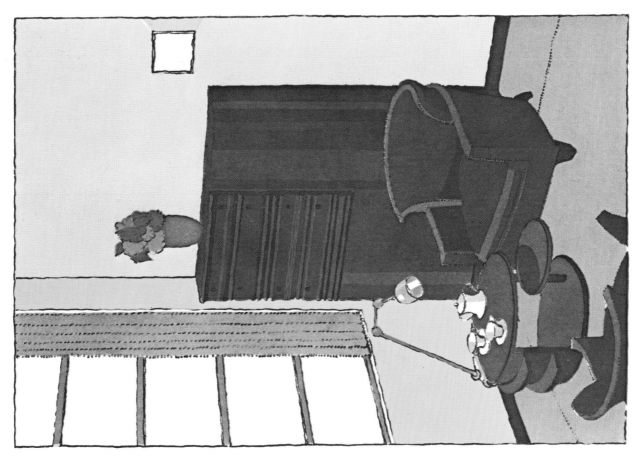

61. Details of man's room, by Etienne Kohlmann

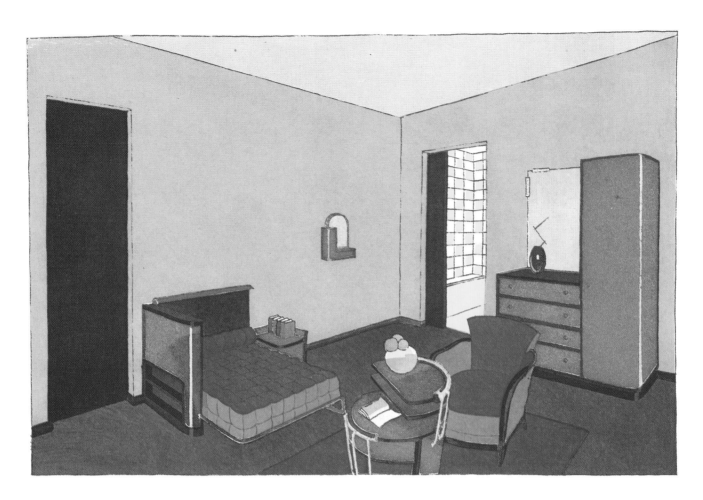

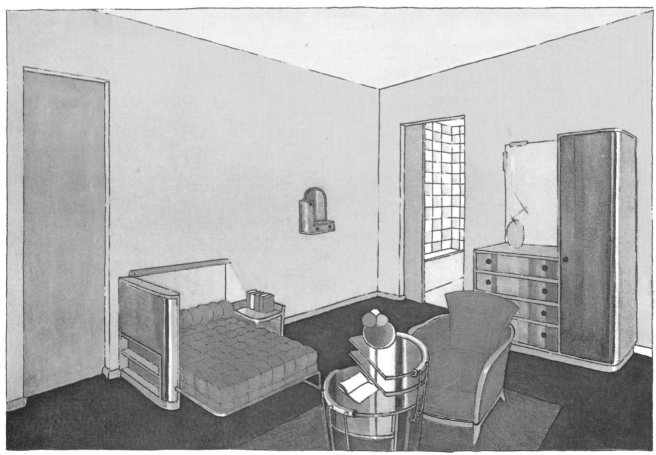

62. Man's room, by Etienne Kohlmann

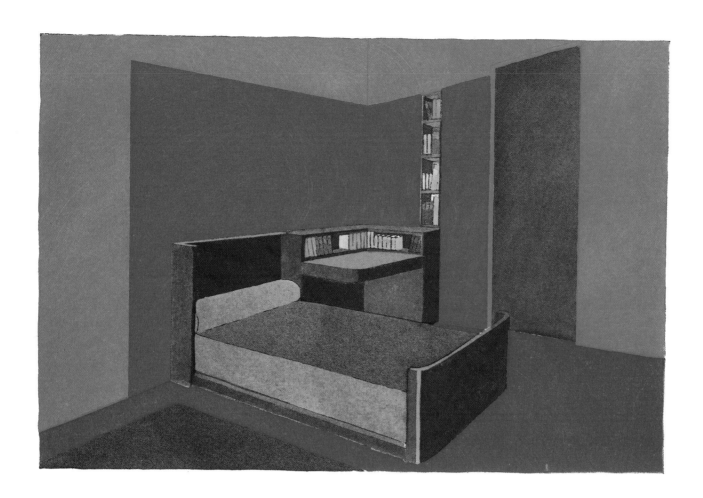

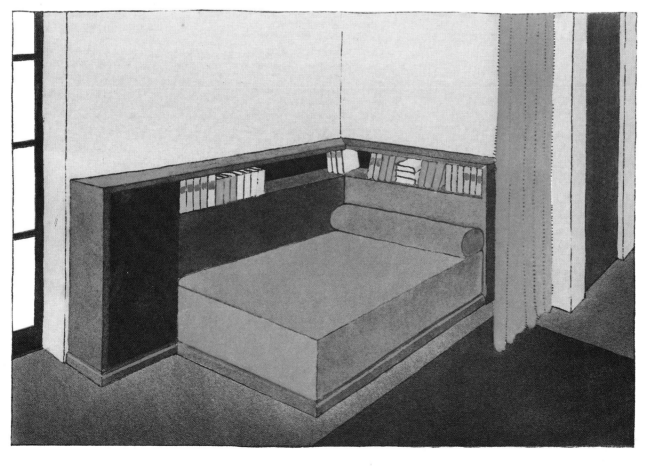

63. Man's room, by Etienne Kohlmann

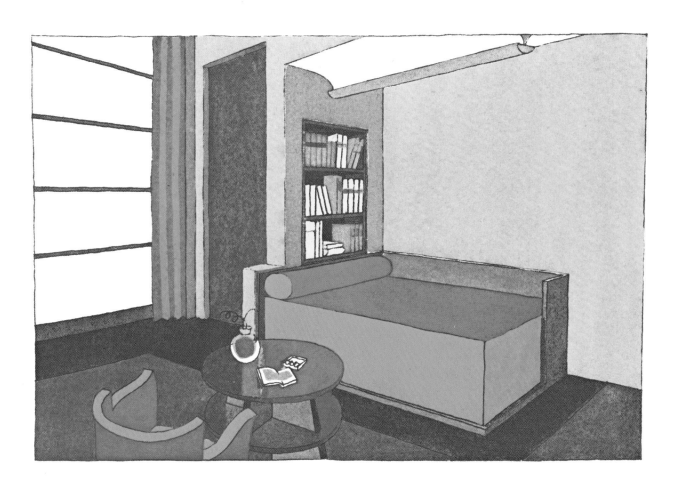

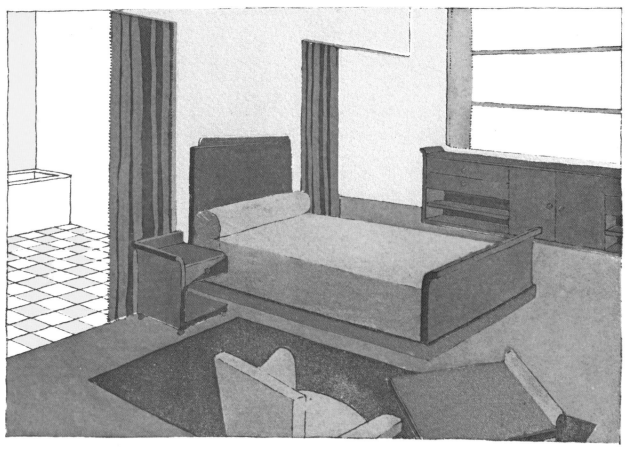

64. Man's room, by Etienne Kohlmann

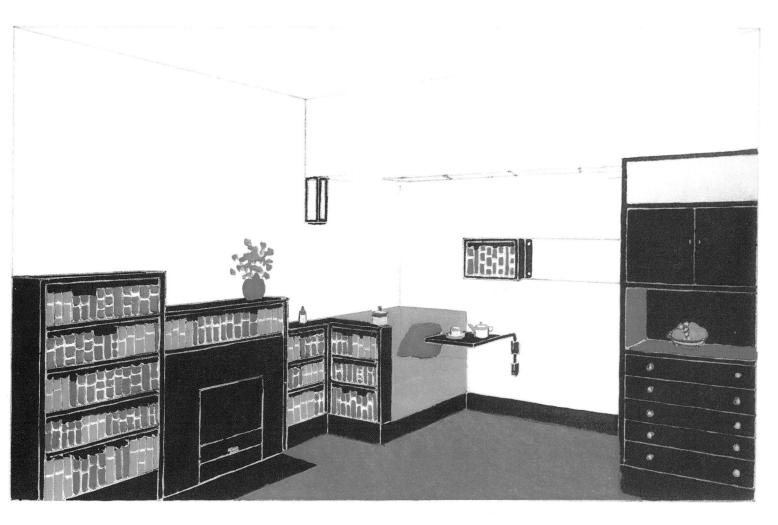

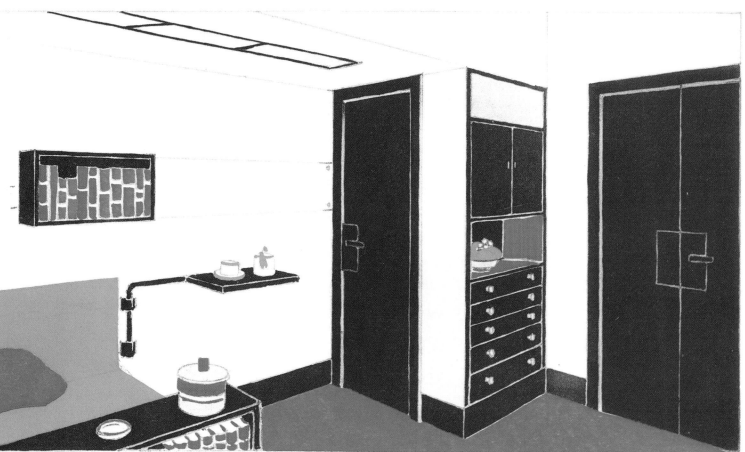

65. Smoking room, by Francis Jourdain

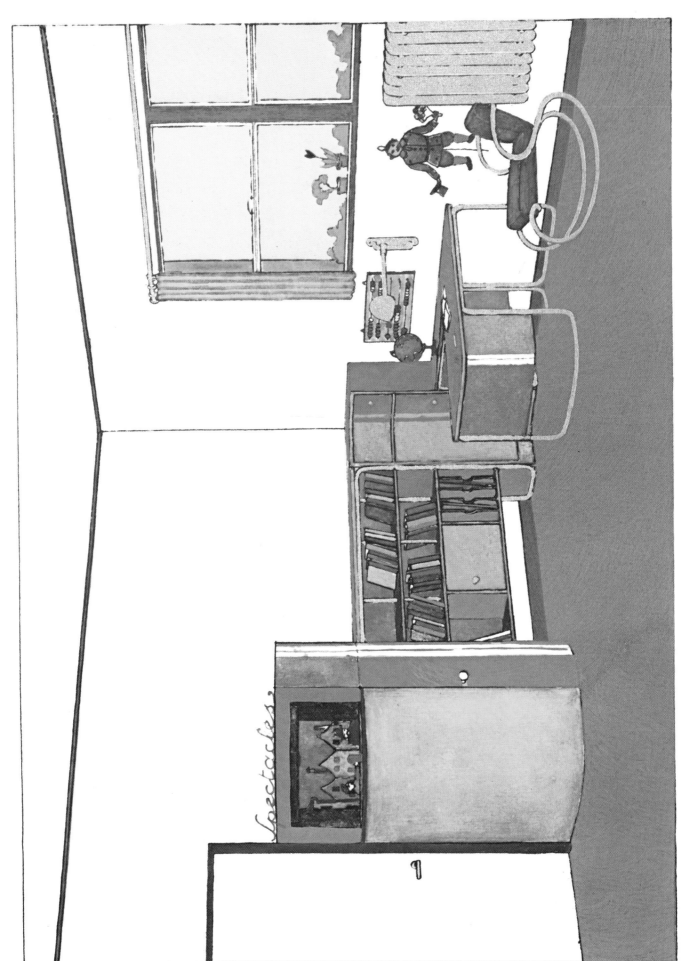

66. Child's room, by Ginsburger

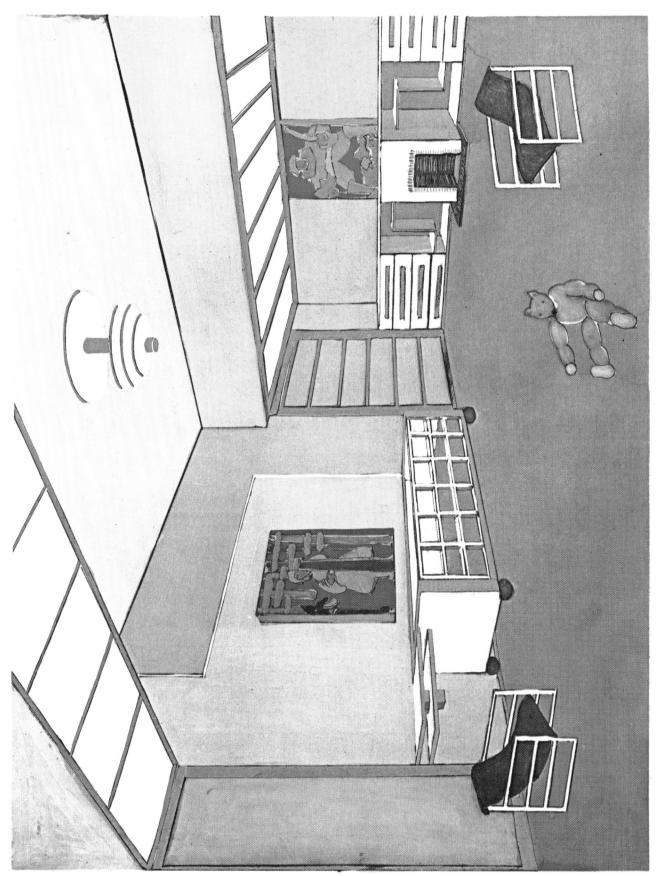

67. Child's room, by Noémi Skolnik

68. Boy's room, by Noémi Skolnik

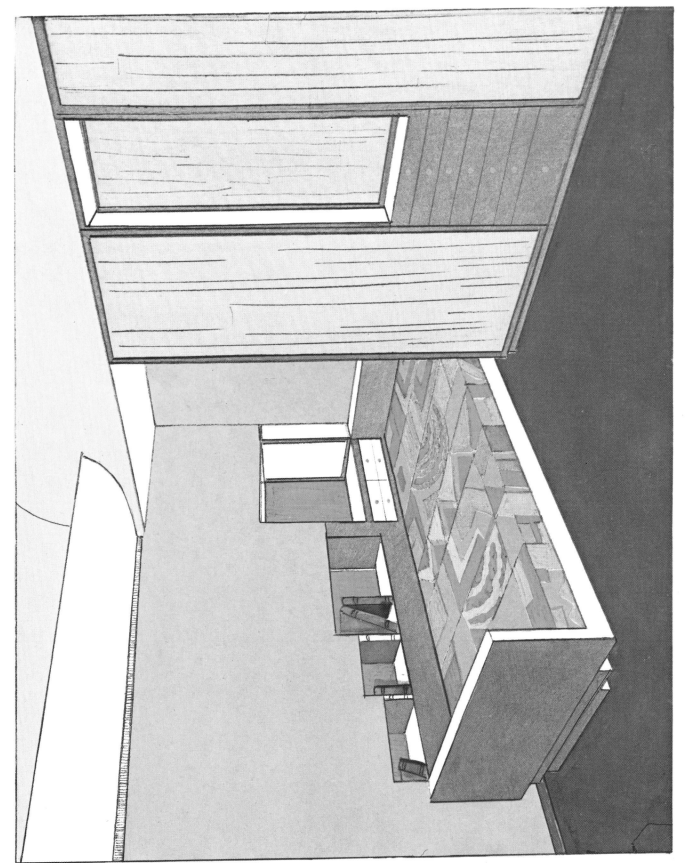

69. Girl's room, by Noémi Skolnik

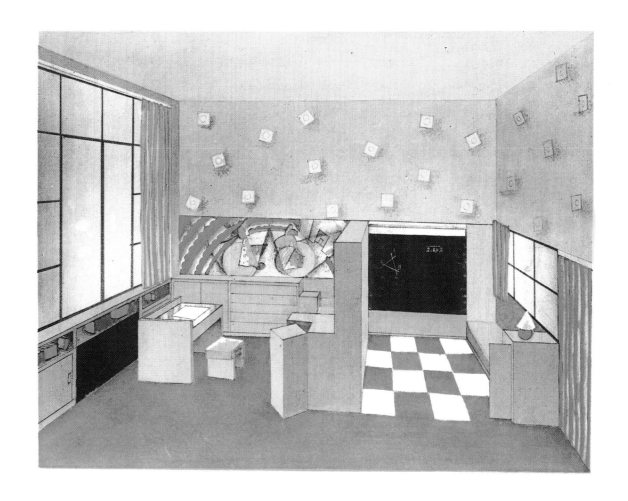

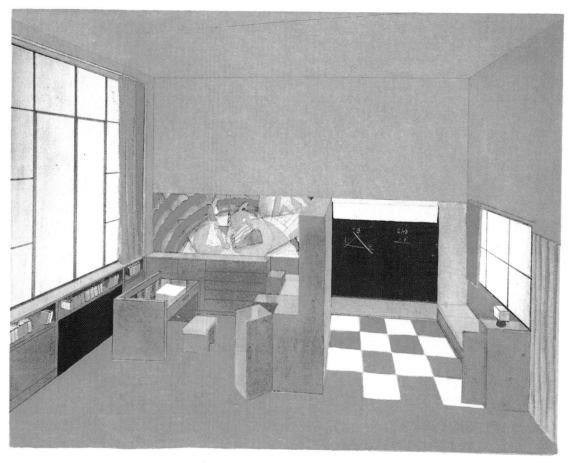

70. Details of child's room, by Jean and Jacques Adnet

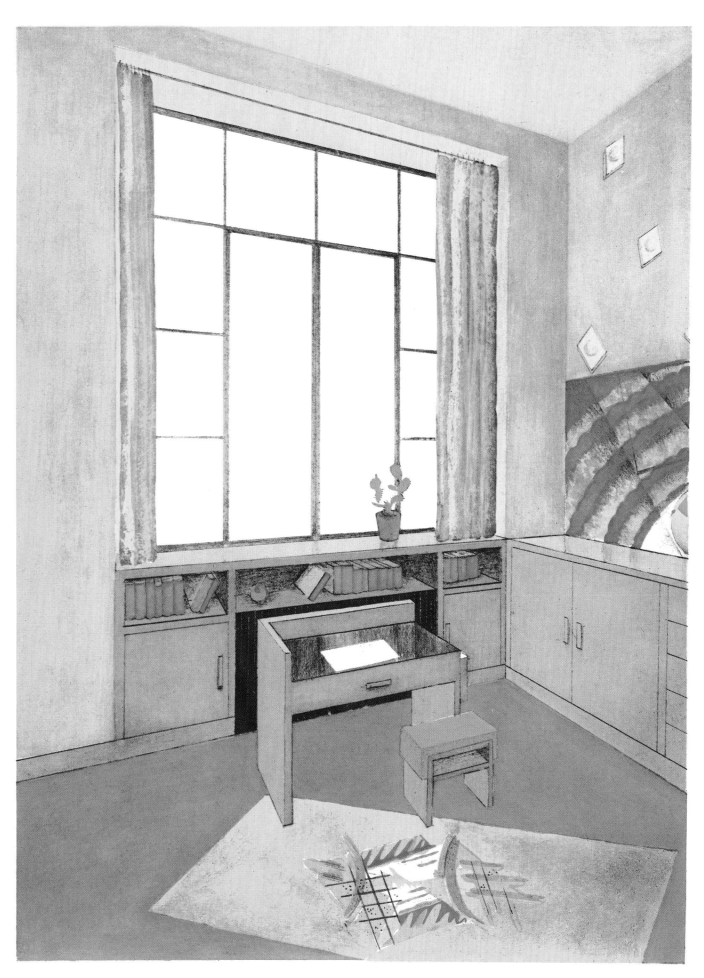

71. Detail of child's room, by Jean and Jacques Adnet

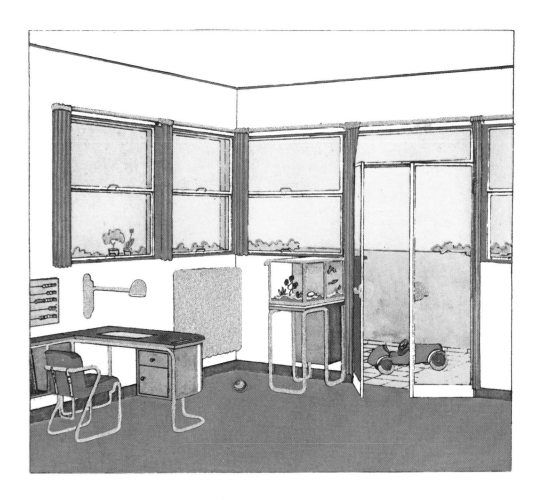

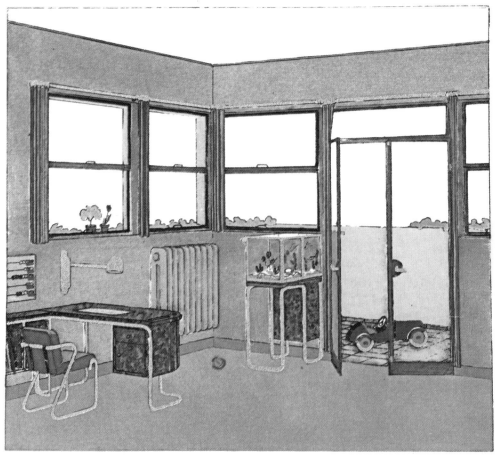

72. Details of child's room, by Ginsburger

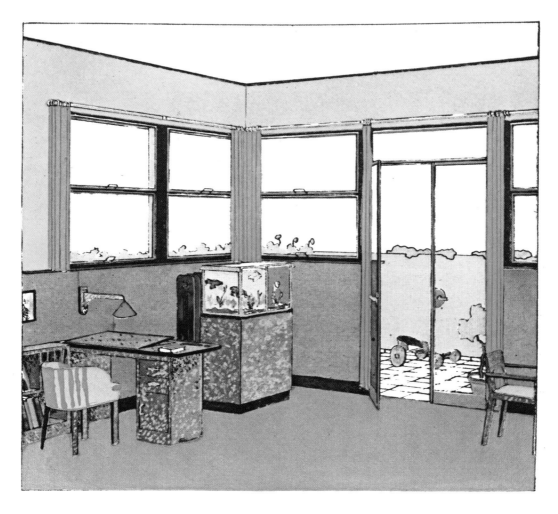

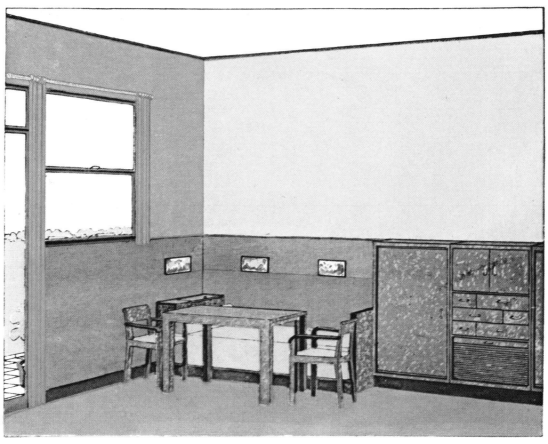

73. Details of child's room, by Ginsburger

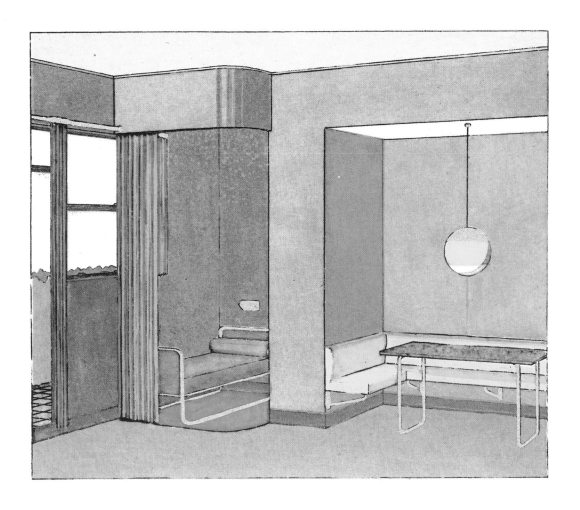

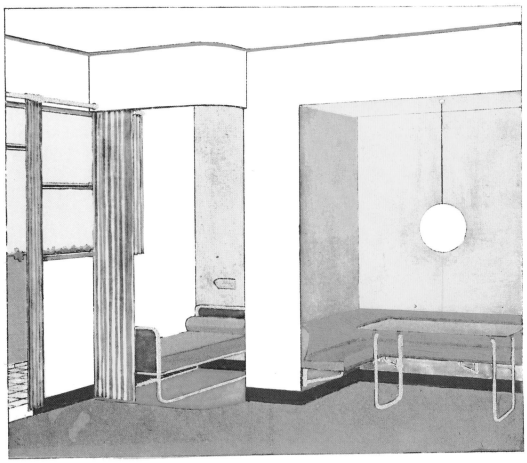

74. Details of child's room, by Ginsburger